BUCKINGHAM PALACE
Official Souvenir Guide

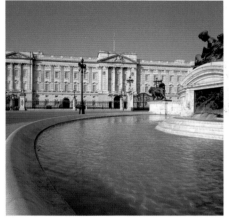

ROYAL COLLECTION PUBLICATIONS

Published by
ROYAL COLLECTION ENTERPRISES LTD
St James's Palace
London
SW1A 1JR

For a complete catalogue of current publications, please write to
the address above, or visit our website at www.royalcollection.org.uk

First published by Royal Collection Publications in 2005.
This edition updated 2006.
© 2006 Royal Collection Enterprises Ltd.
Text by Jonathan Marsden and reproductions of all items in the
Royal Collection © 2006 HM Queen Elizabeth II.

141077/06

ISBN 1 902163 95 8
 978 1 902163 95 6

British Library Cataloguing in Publication Data:
A catalogue record of this book is available from the
British Library.

Designed by Baseline Arts Ltd, Oxford
Production by Debbie Wayment
Printed and bound by The Colchester Print Group

The unique status of Buckingham Palace as a working royal palace
means that paintings and works of art are sometimes moved at
short notice. Pictures and works of art are also frequently lent
from the Royal Collection to exhibitions all over the world. The
arrangement of objects and paintings may therefore occasionally
vary from that given in this guidebook.

For ticket and booking information on the Summer Opening of
the state rooms at Buckingham Palace, please contact:
Ticket Sales and Information Office
Buckingham Palace
London SW1A 1AA

Credit card booking line: (+44) (0)20 7766 7300
Group bookings: (+44) (0)20 7766 7321
Fax: (+44) (0)20 7930 9625
Email: bookinginfo@royalcollection.org.uk
 groupbookings@royalcollection.org.uk
 www.royalcollection.org.uk

Contents

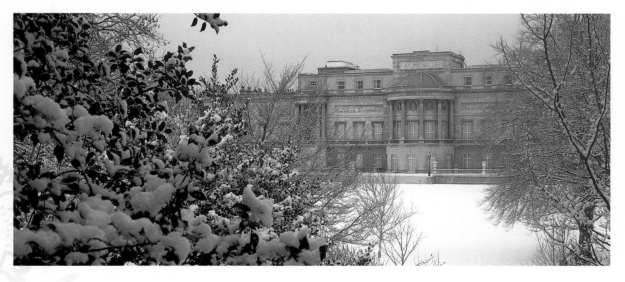

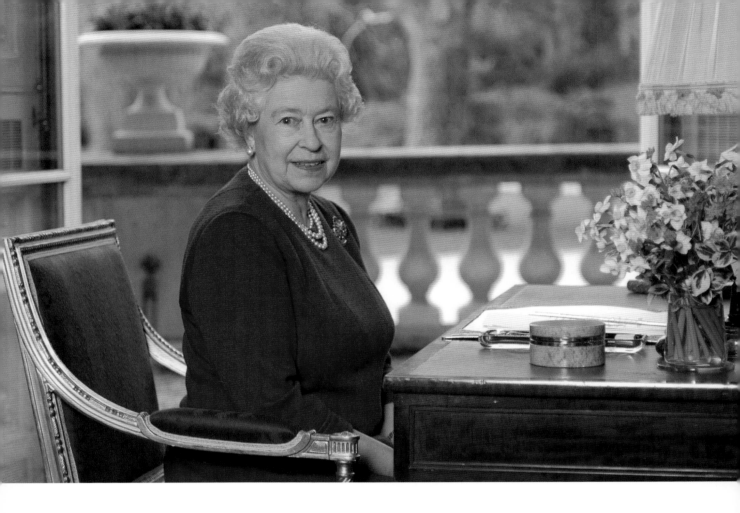

Introduction

BUCKINGHAM PALACE is one of the most readily
recognised buildings in the world. Like the Houses of
Parliament and the red double-decker bus, it stands as
an international symbol of London, and by extension
of the United Kingdom as a whole. It forms the hub
of a part of London whose very shape and appearance are the result of
long-established ceremonial functions. But unlike many of the capital's
most famous historic buildings, it is not a museum. The Palace is the
working headquarters of the monarchy, where Her Majesty The Queen
carries out her official and ceremonial duties as Head of State of the
United Kingdom and Head of the Commonwealth. The Queen
spends the working week at Buckingham Palace, and is normally at
Windsor Castle at the weekend. It is possible to tell at a glance whether
Her Majesty is in residence by looking up at the central flagstaff; if
The Queen is in residence it will be flying the Sovereign's standard.
Otherwise the Union flag will be seen. On great ceremonial occasions,
weather permitting, an especially large standard is flown.

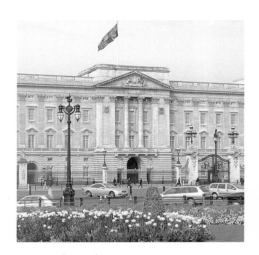

ABOVE: *The Royal
Standard flying during
a state visit.*

4

At Christmas and for the month of January, Her Majesty resides at Sandringham, her private estate in Norfolk, and the months of August and September are spent at Balmoral in the Highlands of Scotland. In recent years the summer interval in The Queen's official programme has enabled public access to the state rooms of the Palace, the rooms in which official functions and receptions take place at all other times. To date the tour has been enjoyed by almost four million people from many parts of the world.

As a constitutional sovereign, The Queen acts on the advice of her ministers. Nevertheless, the Government, the judiciary and the armed services all act in The Queen's name and the monarch is the principal symbol of national unity. The Queen is kept closely informed about all aspects of national life, and each week when Parliament is in session the Prime Minister – eleven have served to date during the present reign – is received in private audience at Buckingham Palace. The Queen also has certain residual 'prerogative' powers, which include the appointment of prime ministers and granting the dissolution of Parliament.

BELOW: *Buckingham Palace and the Victoria Memorial, seen from the air.*

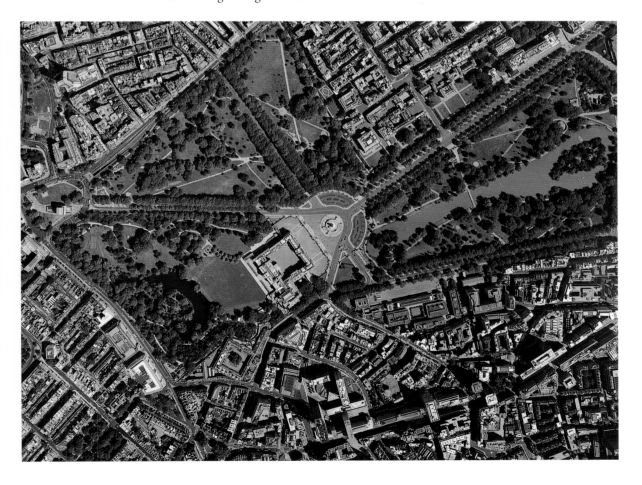

The Queen with members of the British Olympic Team, October 2004.

Many of The Queen's duties are ceremonial and reminders of the long history of the United Kingdom. These include the State Opening of Parliament, The Queen's Birthday Parade (also known as Trooping the Colour), Garter Day at Windsor Castle, and state visits overseas. In between these fixed points in the year, The Queen, The Duke of Edinburgh and other members of the Royal Family undertake several thousand engagements and visits within the United Kingdom, acting as patrons of numerous charitable organisations and providing a focus for undertakings of all kinds on a local, regional and national level. The offices of The Duke of Edinburgh, The Duke of York, The Earl of Wessex, The Princess Royal and Princess Alexandra are also located within the Palace.

Buckingham Palace is one of the few working royal palaces remaining in the world today. This gives it a particular fascination. More than thirty thousand guests from every part of the country and the Commonwealth, drawn from all walks of life, attend The Queen's garden parties in July. A further twelve thousand come as guests or recipients of honours to the twenty investitures which are held each year, and to the numerous receptions held throughout the year. The largest of these, The Queen's Diplomatic Reception, takes place early in November and is attended by approximately thirteen hundred members of the Diplomatic Corps (see page 77).

The highlight of royal entertaining, however, is the state banquet, usually for 170 guests, given by The Queen on the first evening of a state visit by a foreign head of state to the United Kingdom.

THE WORKING PALACE

Some 450 people work in the Palace. In addition to those directly supporting The Queen in the planning and management of her official programme and ceremonial duties, there are those responsible for the maintenance of the building and grounds, for domestic arrangements, for preparing and serving food and refreshments to The Queen's guests and staff, for finance, fire safety, information technology, personnel, communications, and the public opening of the official residences. Most of these are common functions of any large organisation. Then there are those jobs which are uniquely royal, such as the footmen, pages, and yeomen of the pantries (responsible for the china, glass and silver) and those that are nowadays uncommon, such as the fendersmith, the pipe major and the two clockmakers, who maintain more than a thousand clocks in working order.

THE ROYAL COLLECTION

The entire furnishings of the Palace – from the chairs and desks used in many of the offices to the most outstanding paintings and works of art displayed in the state rooms – form part of the Royal Collection, which is held by The Queen as Sovereign for her successors and the nation. The revenues from the public opening of the Palace are received by the Royal Collection Trust, whose aims are to preserve and conserve the Collection and to make it as widely available as possible.

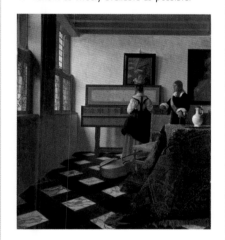

State banquets are held in the Ballroom, the largest of the state rooms, using magnificent gold plate from the Royal Collection, much of it made for George IV (1762–1830).

The state rooms, which form the setting for The Queen's official entertaining, occupy the main (west) block of Buckingham Palace, facing the gardens. In all, the Palace has 19 state rooms, 52 royal and guest bedrooms, 188 staff bedrooms, 92 offices and 78 bathrooms.

The head of the Royal Household is the Lord Chamberlain. Under him are the heads of five departments: the Private Secretary, who plans The Queen's programme, acting as the channel between The Queen and the Government and dealing with appointments, constitutional and political matters; the Comptroller of the Lord Chamberlain's Office, who is in charge of ceremonial; the Keeper of the Privy Purse, who looks after royal finances, property maintenance and personnel; the Master of the Household – a position dating back to 1539 – who is responsible for the organisation of official entertaining; and the Director of the Royal Collection, who is responsible for the care and display of works of art and for managing the opening arrangements for the Palace, the Royal Mews and The Queen's Gallery.

This official souvenir guide provides an account of the history of the Palace, and a guide to the state rooms and their use, and to the works of art on display. Further sources of information are listed at the end of the book.

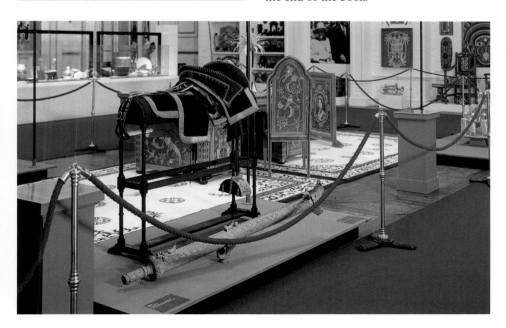

LEFT: *State gifts from the first fifty years of The Queen's reign on display at Buckingham Palace in 2002.*

1 Architectural History

ROYAL PALACES

Among surviving British royal residences, Buckingham Palace has by some way the shortest history. The Tower of London and Windsor Castle *(below)* have remained in use since the late eleventh century, the Palace of Holyroodhouse in Edinburgh since the early fifteenth century, and Henry VIII's palaces of Hampton Court and St James's since the early sixteenth century.

THE FAMOUS EAST FRONT of Buckingham Palace is less than a hundred years old, yet it is known throughout the world, thanks to the twentieth-century expansion of global communication. The construction of the façade itself in 1913 took advantage of recent advances in building technology and was one of the most dramatic and efficient building projects ever seen in London, completed in just three months.

The creation of the Mall frontage was in effect a refacing of the wing that Edward Blore had added for Queen Victoria in 1847, enclosing what had until then been an open, three-sided forecourt. The new wing obscured the more impressive 1820s façade by John Nash with its colonnades and porticos. Nash's Palace was begun in 1825, but was interrupted by the death of George IV five years later and not completed until around 1840, in the early years of the

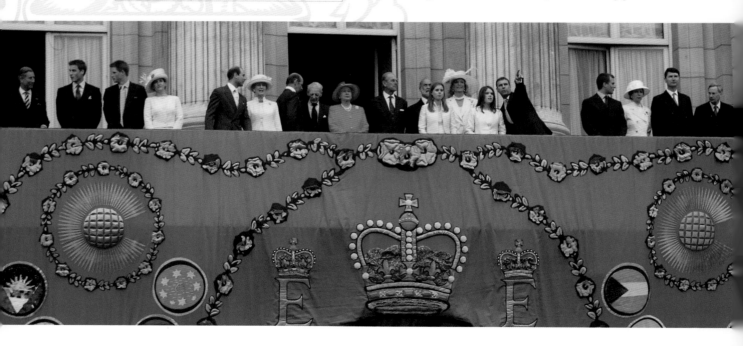

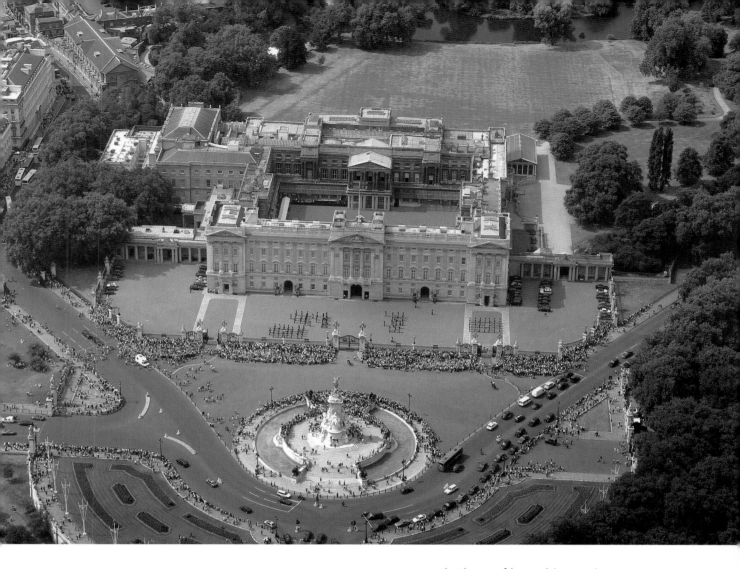

reign of Queen Victoria. Nash's starting-point was a far less imposing building, Buckingham House, which had been purchased in 1762 by George III as a private residence for his wife Queen Charlotte.

At that time, Buckingham House stood on the edge of the city of Westminster, at the western end of the Tudor hunting park of St James's.

ABOVE: *The Changing of the Guard (see page 50) is one of the most popular attractions for visitors to the Palace.*

LEFT: *The Queen's Golden Jubilee. The Royal Family appeared on the balcony on 4 June 2002, when the façade was enriched with a huge patchwork hanging created by the children of the Commonwealth.*

 Before it was a year old, the royal balcony became the focus of national sentiment with the appearance of King George V and Queen Mary on 4 August 1914, the day of the outbreak of the First World War. It has remained so ever since.

Arlington House (rebuilt as Buckingham House in 1702–5).

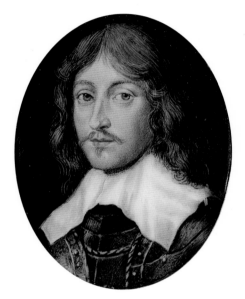

ABOVE: *George, Lord Goring (1608–57) who built 'a fair house' on the site of what was to become Buckingham Palace. A 19th-century copy by an unknown artist of an earlier miniature.*

Earlier buildings

The architectural history of the site of Buckingham Palace reaches back more than a hundred years before it first became a royal house. It was here that in the reign of James I (1603–25) a plantation of mulberries was established under royal patronage for the rearing of silkworms. When the garden was granted by Charles I to Lord Aston in 1628, there was already a substantial house standing. The first documented building work on the site took place in 1633, when George, Lord Goring (1608–57), who had purchased it from Aston's son, built 'a fair house and other convenient buildings, and outhouses, and upon other part of it made the ffountaine garden, a Tarris [terrace] walke, a Court Yard, and laundry yard'. In fact, it seems that he was extending the earlier buildings. By 1668 it had become the home of Henry Bennet (1618–85), Charles II's Secretary of State and later Earl of Arlington. In September 1674 the house was entirely consumed by fire with, as John Evelyn recorded, 'exceeding losse of hangings, plate, rare pictures and Cabinets'. Arlington immediately rebuilt, but to a design which from the solitary visual record (above) appears to have been in the new style of the time, perfected by architects such as Roger Pratt and Hugh May.

In 1698 the house was let on a short lease to John Sheffield (1648–1721), 3rd Earl of Mulgrave and Marquess of Normanby, who was created Duke of Buckingham in 1703. A year later, Sheffield acquired the house outright (or so he thought), and recognising its increasingly dated appearance in an acutely fashion-conscious age, demolished it.

The new house built by the Duke of Buckingham stood exactly on the site now occupied by Buckingham Palace, and its essential plan and the layout of its forecourt dictated all subsequent rebuildings.

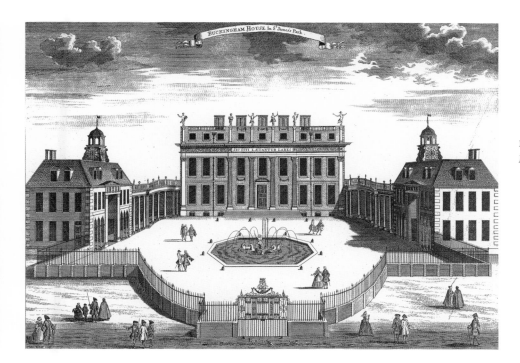

In September 1674 the house was entirely consumed by fire.
'...exceeding losse of hangings, plate, rare pictures and Cabinets'
JOHN EVELYN

THE PALACE'S SETTING

Lord Arlington was able to exploit the newly created axial features of St James's Park, laid out for Charles II by the French royal gardener André Mollet to embellish the settings of the palaces of Whitehall and St James's. These were the long double avenue along the southern edge of St James's Palace, on the line of the Mall, and the long canal extending from Horse Guards to the western edge of St James's Park, itself lined with double avenues.

Despite the grandeur of its setting, or perhaps because the new avenue made the site so very fashionable and exclusive, Arlington House lasted only twenty-five years. Detail from Morgan's Survey of London, 1682.

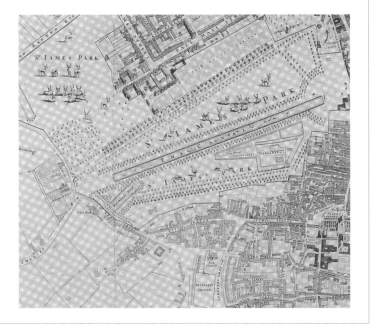

This house was conceived on a far more ambitious scale than its predecessors, and was to be much imitated, particularly by the architects of early eighteenth-century country houses. The first designs were probably prepared by William Talman (1650–1719), Comptroller of Works to William III and the architect of the interior of his new state apartments at Hampton Court. It seems, however, that Talman and Sheffield disagreed and – as Sir John Vanbrugh later put it – the house was 'conducted by the learned and ingenious Capt. Wynne'. This was William Winde (d.1722), who unlike Talman held no official position but was responsible for a considerable number of large and influential houses around the turn of the eighteenth century.

The best contemporary artists and craftsmen were employed on Buckingham House, including the mural painter Louis Laguerre and the sculptor John Nost, who provided statues of *Apollo, Liberty, Equity, Mercury, Truth* and *Secrecy* for the parapet. The handsome screen and gates in the foreground were almost certainly made by the Huguenot smith Jean Tijou. At the centre of the forecourt stood a magnificent fountain with *Neptune in Triumph*, most probably by the Burgundian sculptor Claude David.

In his ambition to build what amounted almost to a private palace, the Duke of Buckingham unwittingly encroached on the former

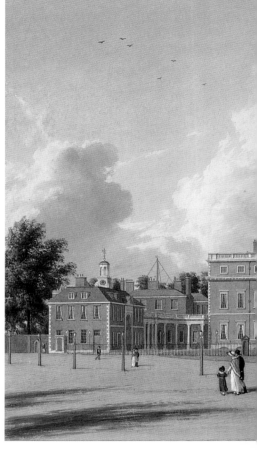

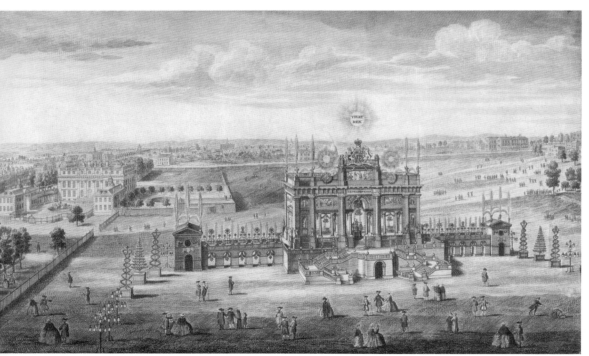

ABOVE: *Buckingham House as it was in 1819, in a watercolour by William Westall. George III simplified the façade of the Duke of Buckingham's house and added substantially to the north and south sides.*

LEFT: *Fireworks in Green Park for the Peace of Aix la Chapelle 1749. Buckingham House can be seen on the upper left side. Engraving by J-B.Chatelain.*

RIGHT: *State portrait of George III by Allan Ramsay, 1761–2*

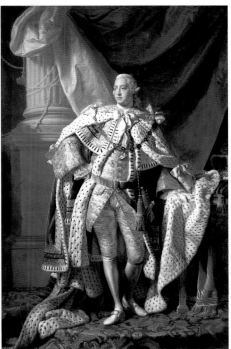

royal Mulberry Garden. This did not become an issue until much later when, following the death in 1742 of the Duchess of Buckingham, the house was in the hands of the Duke's illegitimate son. It was John, 3rd Earl of Bute, George III's mentor and adviser, who began in 1761 to engineer the purchase of the house for the King. Sir Charles Sheffield was obliged to part with it for £28,000.

This could not have come at a more fortuitous time, for it was in September 1761 that the new King George III welcomed his bride Princess Charlotte of Mecklenburg-Strelitz to England. The marriage ceremony took place in the Tudor palace of St James's which, though modernised under Queen Anne and George II, was conspicuously uncomfortable. The acquisition of Buckingham House instantly provided the King with a more appealing alternative; he explained to Lord Bute that it was 'not meant for a palace, but a retreat'. It would become the King and Queen's London residence, while St James's was maintained as the official seat of the court.

The Queen's House

The young George III lost no time in taking possession of his new house. In the spring of 1762 he wrote to Lord Bute:

> *...there seems to Me but little necessary to make it habitable; as to the Furniture, I would wish to keep nothing but the Picture in the Middle panel of the Japan Room, & the four glasses in the Room, they all having Japan frames... All I have to recommend is dispatch that I may soon get possession of it...*

Notwithstanding this initial reaction, considerable amounts of work were put in hand, and between 1762 and 1776 the house was transformed, both inside and out, at a cost of £73,000.

Beginning with the exterior, the King ordered the refacing of the east front, removing the more ornate Baroque features, such as Nost's statues and the fountain in the forecourt, and substituting a central frontispiece of four fluted pilasters in place of Talman's six. Tijou's extravagant gates and their railings were swept away in favour of a much simplified, lower arrangement which gave an air of informality to the front. All this work was managed by the Surveyor of the Board of Works, Thomas Worsley, to designs by the King's tutor in architecture, William Chambers. In 1775 the house was settled on Queen Charlotte in exchange for Somerset House,

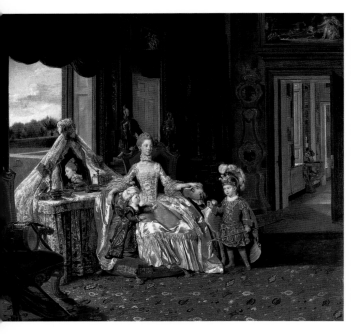

TOP: Queen
Charlotte with her
two eldest sons, *by
Johan Zoffany, c.1765;
painted in one of the
King's rooms on the
garden front of
Buckingham House.*

BELOW: *Queen
Charlotte's Saloon on the
first floor of Buckingham
House. Watercolour of
1818 by James Stephanoff.*

which had been a royal residence for centuries but was now to be
devoted to the use of various government departments. From this
time onwards, Buckingham House became known simply as 'the
Queen's House'.

Adam and Chambers held office as the 'joint architects' of the
Office of Works, and both had a hand in the design of new
interiors, chiefly those devoted to Queen Charlotte's use. The King
himself, having studied architecture under Chambers, contributed
his own designs for doorcases. The Queen's rooms on the principal
floor were among the most sophisticated of their date in London,
with ceilings designed by Robert Adam and painted by Giovanni
Battista Cipriani, while the King's rooms on the ground floor were
markedly simple in comparison.

Johan Zoffany's paintings record the family life that George III
and Queen Charlotte valued above all other things, and of which
the Queen's House was the focus. It was here that all but one of
their fifteen children were born, and here they had their nurseries
and governesses. When, following the deaths of both George III
and Queen Charlotte, decisions had eventually to be taken about
the future of the house, George IV made clear that there were
'early associations which endear me to the spot'.

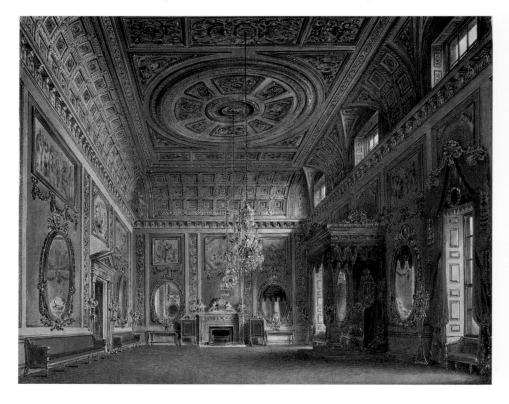

GEORGE III'S LIBRARIES

King George III devoted an extraordinary amount of space to his collection of books. At the time of his accession, the royal library was negligible, his grandfather George II having presented nine thousand volumes to the British Museum in 1757. In December 1762, in the same year that Buckingham House was acquired, George III purchased a large and significant collection of books, paintings, drawings, coins and engraved gems from the British Consul in Venice, Joseph Smith. While the paintings, which included more than fifty by Canaletto, were ideally suited for the walls of Buckingham House, the books could not be accommodated without further architectural changes. Between 1762 and 1764, a substantial new room, the Great or West Library, was built on at the southern end of the ground floor to designs by Chambers; and in 1766–7 two further rooms were added, including a vast octagonal space (below) with bookshelves on two levels. Yet another rectangular library was built later, as the King's collection of books – which he formed as the basis of a national library with the advice of Dr Samuel Johnson and others – continued to grow. When eventually given to the British Museum by George IV in 1824, the library comprised 65,000 volumes and 19,000 unbound pamphlets, together with 40,000 cartographic and topographical items. It was described in the *Quarterly Review* as 'the most complete private library in Europe'.

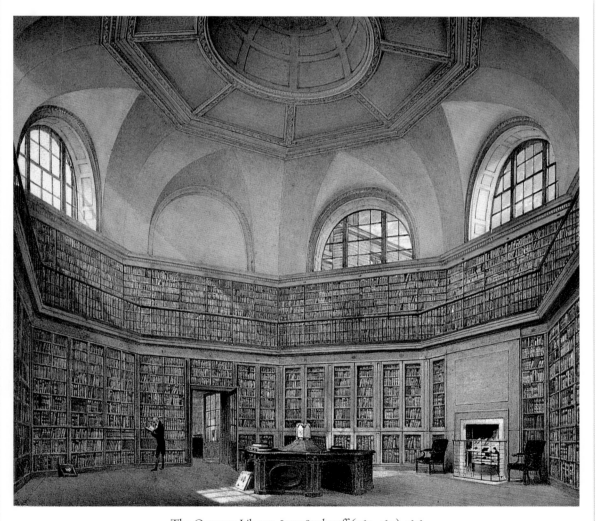

The Octagon Library, *James Stephanoff (1789–1874), 1818*

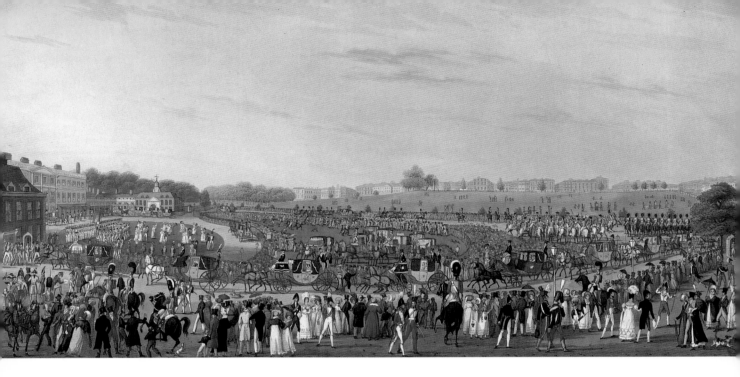

John Nash and Buckingham Palace

Guests arriving for a royal Drawing Room at Buckingham House in 1822. Engraving by G. Humphrey.

The problem that faced the new King, George IV, in 1820 was to decide where the official business of privy councils and audiences, and the ever increasing obligations attaching to the monarchy to entertain and receive large numbers of guests, should take place. His own London residence, Carlton House, halfway between the Queen's House and Whitehall along Pall Mall, was not suitable. Already in the first decades of the new century, the balance had tipped emphatically away from St James's Palace and towards the Queen's House, which had begun to lose all semblance of the private retreat for which it had first been intended. Despite this, in George IV's coronation year of 1821 the architect John Nash was instructed by the Board of Works to refurbish the state apartments at St James's for the use of the new King. These were completed in 1824, at a cost of £60,000.

This was mere window-dressing, however. As the architect responsible for the maintenance of St James's, Nash had repeatedly recommended its demolition after half of the old state apartments had been destroyed by fire in 1809 and, magnificent as they were, his new apartments comprised only three principal rooms. Foreign visitors and journalists remarked with increasing frequency on the fact that in the burgeoning capital city of the greatest power in the world there was no proper royal palace. A number of speculative designs for a new palace were published in the form of engravings or pamphlets. Sir John Soane, who held a similar official position as Attached Architect in respect of the Queen's House to Nash's at St James's, devised a most ambitious plan in 1817 for a new palace at Hyde Park Corner.

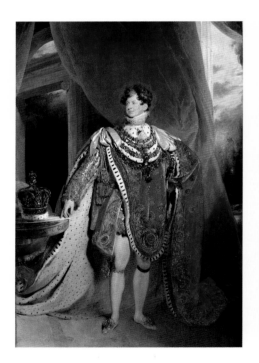

State portrait of George IV by Sir Thomas Lawrence, 1821. The Table of the Grand Commanders, one of the treasures of the Royal Collection, can be seen on the left of the painting. Today it is in the Blue Drawing Room (see page 83).

Portrait of John Nash
(1752–1835) by Sir
Thomas Lawrence, 1824.

In July 1821 responsibility for Buckingham House was transferred from John Soane to John Nash, who since 1813 had been engaged on the final transformation of the Royal Pavilion at Brighton, becoming in the process a close confidant of the new King. More significantly perhaps, in 1820 he was charged by the Board of Works to relocate the King's Mews at Charing Cross to a new stable complex (now the Royal Mews) to be built next to Buckingham House. The choice suggests that the site was being looked at afresh as the principal seat of the crown. While Nash was occupied on the Mews and on the new state rooms at St James's, little was done to Buckingham House itself, but in May 1825 the architect was instructed by the Chancellor of the Exchequer to prepare plans for the enlargement and modernisation of Buckingham House for approval by the King. These having been duly accepted, a Bill was laid before Parliament for the 'repair and improvement' of Buckingham House, proposing the application of Crown Lands revenues (the income from the Crown Estate, which George III had surrendered to the Exchequer in return for an annual grant known as the Civil List).

In fact, before the Bill had passed through Parliament, the first contracts were in place for what clearly amounted to far more than 'repair and improvement', and Nash had taken steps to secure the supply of unprecedented quantities of bricks, stone and timber. His first estimate, £252,690, was not submitted for another year and even then it contained many uncertainties, foreshadowing the difficulties that would ensue from the confusion over the scope of work and lines of authority.

Nash's design was essentially an enlargement of the plan of Buckingham House. The central block was extended westwards and to the north and south, and the two wings to the east were rebuilt in much the same style as Nash had deployed on the Regent's Park terraces. The wings enclosed a forecourt or *cour d'honneur* which would transform the aspect of the new Palace from St James's Park, which in George III's time had been markedly informal.

In May 1825 the architect was instructed by the Chancellor of the Exchequer to prepare plans for the enlargement and modernisation of Buckingham House for approval by the King

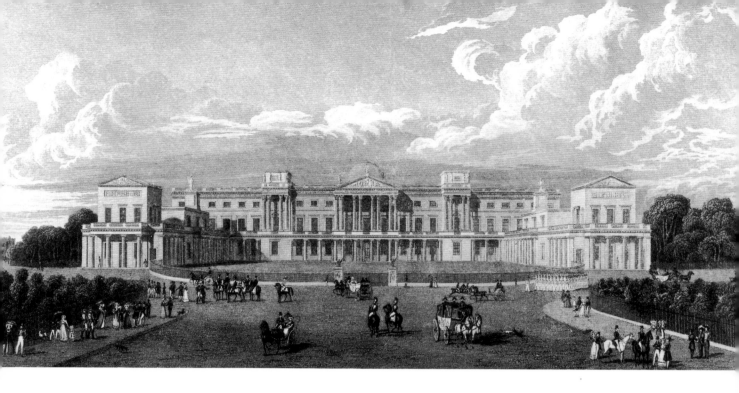

The East Front as first designed by Nash, from a drawing by A.C.Pugin of 1825. The wings were partly demolished and rebuilt in 1828.

When first completed, the wings were a single storey in height, rising to two storeys at their centres and three at their eastern ends. At the centre of the new East Front was a colossal double portico supporting a sculptural pediment. These new features were greeted with a furore of public and official criticism. The outcome was that the wings were rebuilt to the same height as the main block, and terminated with pedimented porticos that referred back to the centrepiece of the main East Front. In the centre of the forecourt, between the two wings, there was to be a triumphal arch, inspired perhaps by that of Constantine in Rome, but no doubt more directly based on the *Arc de Triomphe du Carousel* which Napoleon's architects Percier and Fontaine had recently erected in a similar position at the Tuileries in Paris. The arch was intended as part of a ceremonial processional approach to the Palace and would be a celebration of recent British naval and military victories, with friezes in honour of the Duke of Wellington and Lord Nelson on each side, and surmounted by a bronze equestrian statue of George IV.

The East Front as completed, with the Marble Arch at the centre of the forecourt. Watercolour by Joseph Nash, 1846.

The changes and additions to the design added greatly to the cost, which had risen by 1828 to £496,169. By 1831, the year following George IV's death, the final cost of the rebuilding was forecast at £696,353, and by the time the Palace became habitable at the beginning of the reign of Queen Victoria six years later, approximately £800,000 had been expended.

For all the controversy that surrounded its construction, which to some extent has always accompanied public building projects on this scale, Nash's Buckingham Palace was a masterpiece, exactly answering

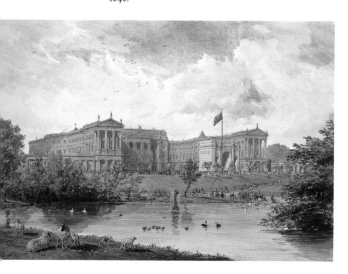

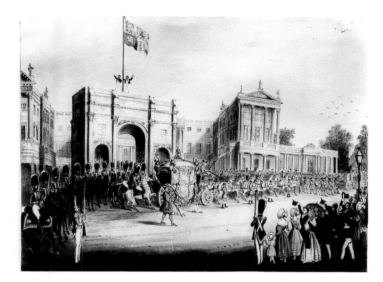

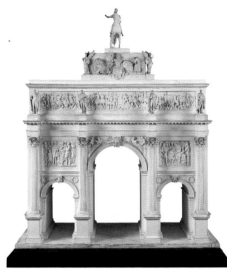

LEFT: *Queen Victoria's coronation procession passes the Marble Arch. Engraving of 1838.*

BELOW: *John Nash's proposal model for the Marble Arch, showing the intended friezes and the statue of George IV.*

the need – so long felt and so often expressed – for a palace that reflected Britain's standing in the world and provided a suitably dignified setting for the Sovereign and court. The ingredients were the advanced, French-inspired Neoclassical design, the quality of the materials and detailing, the involvement of outstanding artists and craftsmen in all aspects of the work, and what one early critic termed 'the impress of nationality' that was to be found in every detail.

Among the craftsmen, the metalworker Samuel Parker exemplifies a particular moment in the history of British manufacturing when technical innovation was combined with versatility and

The east Quadrangle Front. At the angles of the pediment there originally stood Coade stone figures of Britannia, Commerce and Neptune, with naval and military trophies at intervals along the parapet, also in Coade stone.

entrepreneurial skill. At Buckingham Palace, Parker's work can be found in the finest gilt-bronze mounts embellishing a Chinese vase, in the magnificent gilt-bronze balustrade of the Grand Staircase, and in the ornaments of the mahogany doors and the marble capitals. He also supplied the railings of the forecourt and the gates of the Marble Arch.

John Flaxman (1755–1826), Professor of Sculpture at the Royal Academy, was in overall charge of the architectural sculpture and prepared drawings, but his death only one year into the building project prevented him from undertaking any of the work himself. Most of the internal plaster decorations were designed by Thomas Stothard (1755–1834), a versatile painter and book illustrator. Ever since the Elgin Marbles went on display for the first time at the British Museum in 1817, the Parthenon sculptures had become a touchstone among sculptors and artists, who flocked to make studies and casts. A processional frieze became almost *de rigueur* for new public buildings in the following decade. Stothard's genius turned Grecian into Gothic for the distinctly British friezes he designed for the Throne Room at Buckingham Palace, which represent scenes from the Wars of the Roses. Subjects from British history were also chosen for the friezes on the West Front and the Marble Arch, while elsewhere a play was made on the themes of *procession* and *progress*, in J.E. Carew's frieze of *The Progress of Navigation* (designed by Richard Westmacott) under the central portico, and William Pitts's *Progress of Rhetoric* in the Music Room and *The Origin and Progress of Pleasure* in the White Drawing Room.

The form of the Corinthian capitals employed by Nash for the principal storey of the exterior and for most of the interiors was based on an example from the Pantheon in Rome, of which a cast was obtained for the purpose by Joseph Browne, the stonemason and contractor whom Nash employed to procure marble for use in the Palace.

NEW TECHNOLOGY

Nash was alive to the possibilities afforded by new technology, such as the structural use of cast iron. Not only the principal joists concealed within the structure, but all the Doric columns of the ground floor were cast in Staffordshire and brought to London by the newly available network of canals. Plate glass for the windows and the mirrored and glazed doors was available from suppliers in Vauxhall using the latest processes, and for the friezes and external capitals Nash was able to turn to William Croggon, successor to Mrs Eleanor Coade in the manufacture of artificial stone.

RIGHT: *The ceiling of the Music Room is formed of ever-decreasing compartments enclosing the flowers of the kingdoms of England, Scotland and Ireland.*

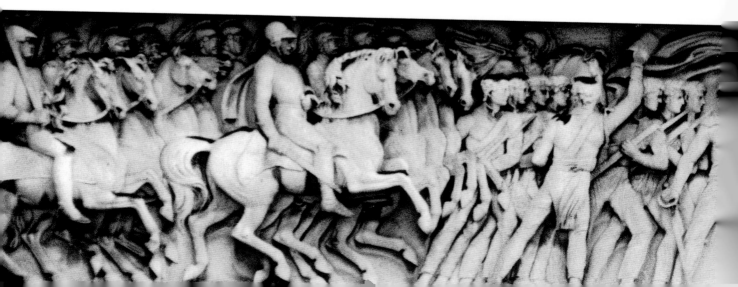

National devices also appear in the continuous Coade stone frieze of the Quadrangle façades, designed by John Flaxman and made by William Croggon, which incorporates the rose, shamrock and thistle; and in the plaster ceilings, especially that of the Music Room. The Throne Room is at once a theatre and a national temple, replete with heraldic imagery.

> *No sooner was the King dead than the Prime Minister, the Duke of Wellington, intervened to 'make a Hash of Nash', and to call a halt to further expenditure*

It is striking that the project as a whole was largely undertaken by men over sixty years of age. The King himself was 62 when work began, while Nash was 73 and Stothard and Flaxman were 70. By the time of the King's death in 1830 the Palace was far from finished, and he never made use of it. Much of the fitting-out of the state rooms – floors, chimneypieces and so on – remained to be completed. Very little had been done about furniture, and scarcely any progress had been made with the functioning parts – the 'necessary offices' such as the kitchens and laundries that would make it habitable. No sooner was the King dead than the Prime Minister, the Duke of Wellington, intervened to 'make a Hash of Nash', and to call a halt to further expenditure.

BELOW: *Portland stone frieze by Richard Westmacott (1775–1856),* The Battle of Waterloo, *1828–32. Intended for the Marble Arch but never fixed in place, it was later inserted in the parapet of the East Front of the Palace, together with Westmacott's other frieze* The Death of Nelson.

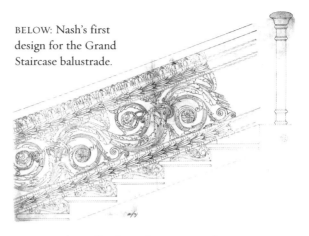

BELOW: Nash's first design for the Grand Staircase balustrade.

BELOW: John Bull calls Nash to account for his over-expenditure on the Palace. *In 1828 and 1831 the construction project was examined by Select Committees of Parliament, to which Nash and each of his contractors in turn submitted evidence, while other leading architects and engineers were called to give their opinion on the structural integrity of the building. Engraving by William Heath, 1829.*

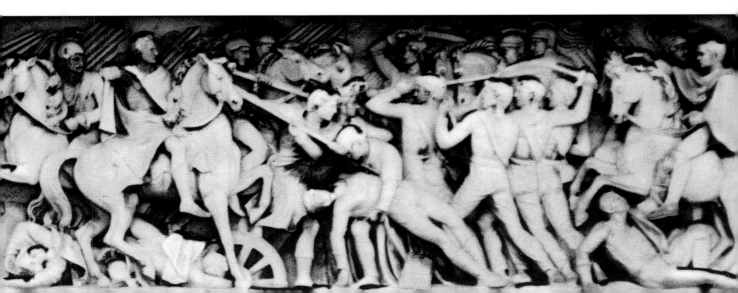

The completion of the Palace

Nash was dismissed, and the task of seeing the Palace through to completion fell to Lord Duncannon, First Commissioner of Woods, who appointed Edward Blore (1787–1879) as architect. The new King William IV, George IV's brother, showed no interest in moving from Clarence House, which Nash had recently built for him within St James's Palace. Indeed, so little did he care for his brother's new Palace that when in 1834 the old Houses of Parliament were destroyed by fire, the King offered the still-incomplete building as a ready-made replacement. The offer was respectfully declined, and a sum of £55,000 was voted by Parliament to allow the 'completing and perfecting' of the Palace for royal use.

Unlike Windsor, where George IV had been rebuilding the old private and semi-state apartments at much the same time, the furnishing stage was never reached at Buckingham Palace during the King's lifetime. What plans there were had been based on the assumption that Carlton House – which was to be abandoned as a royal residence, and was demolished in 1827 – would contribute the greater part of the pictures and other furnishings. These were

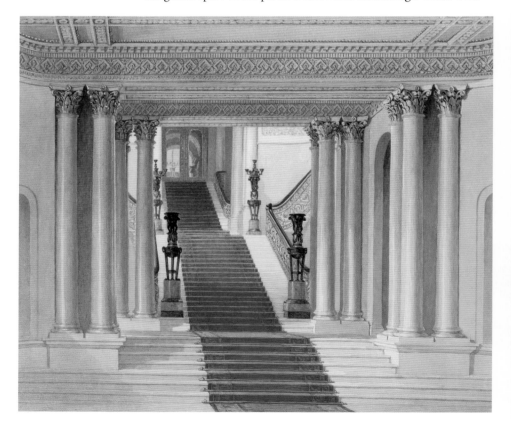

Watercolour of the Grand Staircase by Douglas Morison, 1845, depicted after the failure of Nash's colourful scagliola panels and just in advance of the new decorations devised by Prince Albert and Ludwig Gruner.

supplemented by some of the pre-existing contents of the Queen's House, and by surplus furnishings from Windsor: in February 1834, 120 pieces of furniture and a number of tapestries were removed from the Castle to London by the royal furnishing firm of Thomas Dowbiggin, and a further 'considerable portion of furniture' was delivered to the Palace from the Carlton House riding school, which served as a store following the demolition of the house itself.

Blore's somewhat thankless work involved the completion of the state apartments to Nash's designs, and the provision of all the necessary offices. He extended the east façade at both ends, providing a guard room at the southern end and a matching screen at the northern end. Beyond the guard room to the west, Blore created a new entrance (the 'Ambassadors' Entrance'), through which those with the privilege of *entrée* would be admitted to Drawing Rooms.

Work on the Marble Arch was halted and Blore made use of those sculptural elements that had been completed elsewhere. The two largest friezes, Westmacott's *Death of Nelson* and *Napoleon's Flight from Waterloo*, were mounted, in truncated form, high on the east elevation of the main block, to either side of the portico.

'Headquarters of Taste'

Soon after Queen Victoria moved into the Palace at the start of her reign in 1837, Blore was charged with fitting out the southern of the two conservatories on the garden front as the Private Chapel. It was consecrated in 1843. In February 1845 Queen Victoria wrote to the Prime Minister, Robert Peel, about the 'urgent necessity of doing something about Buckingham Palace'. She pointed out:

> ...the total want of accommodation for our little family, which is fast growing up. A large addition such as alone could meet the case could hardly be occupied before the Spring of 1848, if put in hand forthwith, when the Prince of Wales would be nearly seven, the Princess Royal nearly eight years old, and they cannot possibly be kept in the nursery any longer...

> A room capable of containing a larger number of those persons whom the Queen has to invite in the course of the season to balls, concerts etc. is much wanted. Equally so, improved offices and servants' rooms, the want of which puts the departments of the household to great expense yearly.

When visiting her friend and Mistress of the Robes, Harriet, Duchess of Sutherland, at Stafford House in St James's (now Lancaster House), the Queen famously joked that she was coming 'from my house to your palace'

Sir Edwin Landseer, Queen Victoria and Prince Albert at the *Bal Costumé* of 12 May 1842.

By far the most significant element of Blore's design was the central balcony

The Return of the Guards from the Crimea. *Watercolour by William Simpson, 1856.*

The Queen left it to Peel to decide whether all of these deficiencies should be addressed at once. Edward Blore was once again consulted, and he advised in favour of this approach, but Peel was no doubt mindful of a general sensitivity over the cost of public building projects arising from the comprehensive rebuilding of the Houses of Parliament, which had recently begun. Blore was therefore instructed to prepare plans for a new wing, enclosing Nash's forecourt on its eastern side, to provide the necessary increase in domestic and office accommodation. The project was hedged about from the start by the strictest economic constraints. Blore would be instructed by the Commissioners of Woods and Forests, who themselves appointed an advisory group of other eminent architects including Robert Smirke and Charles Barry (responsible for the British Museum and the Houses of Parliament respectively). Despite these safeguards, it was decided to face the new wing in limestone from Caen in Normandy, which had been imported to England for centuries but had hitherto only been used internally. As early as 1866 it had begun to decay severely in London's polluted air, and for the last forty years of the nineteenth century the defects had to be concealed beneath layer upon layer of paint.

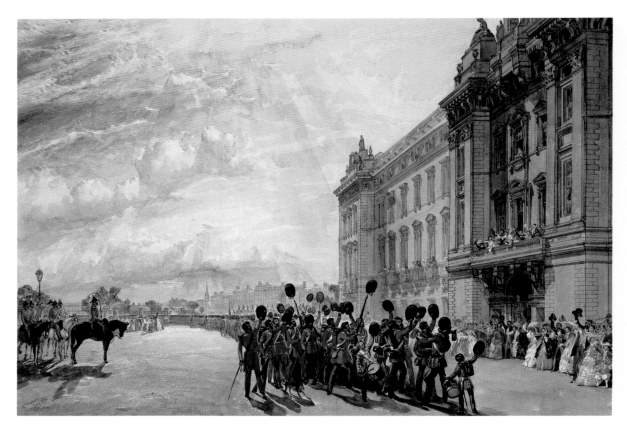

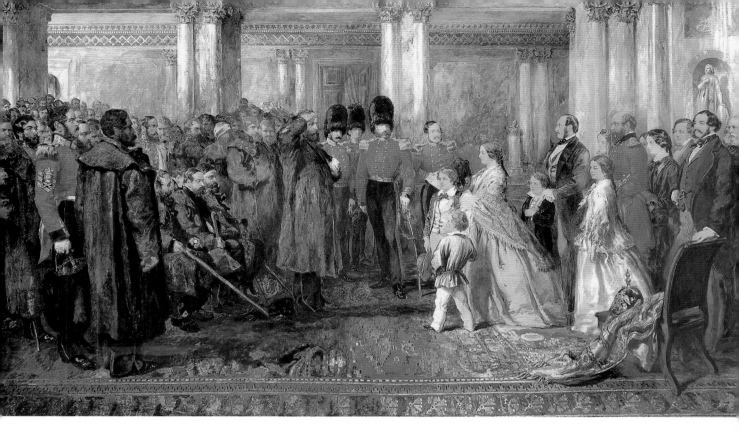

Queen Victoria inspecting wounded Coldstream Guardsmen in the Hall of Buckingham Palace, 22 February 1855. *Watercolour by John Gilbert, 1855.*

As well as obscuring Nash's Palace from public view, Blore's new wing represented a complete departure in style. The façade was of three storeys, and the central frontispiece had giant Corinthian pilasters and a sculptural cresting of *The Four Ages of Man* flanked by groups of *St George and the Dragon* and *Britannia*, all carved by John Ternouth (1795–1849). The new wing put paid to the two temple fronts with which Nash had completed the north and south wings, and Blore recycled and reshuffled some of the decorative sculpture from these compositions. By far the most significant element of Blore's design was the central balcony, which was incorporated at Prince Albert's suggestion. From here Queen Victoria saw her troops depart to the Crimean War, and welcomed them on their return.

The undertaking of the building work, from 1847 to 1850, was organised on a completely different basis from the system in place under Nash twenty years earlier. Whereas then, each trade had negotiated separately with the architect for their particular component of the building, this time the entire work was put in the hands of a single contractor, who was in turn responsible for placing subcontracts with the specialist trades. This task fell to Thomas Cubitt (1788–1855), the enterprising builder and developer responsible for the face of much of Victorian London as the contractor for the Bedford and Grosvenor estates. He was also employed at this time by Prince Albert in the construction of Osborne House on the Isle of Wight, working largely to the Prince's own designs.

The construction of the new wing was closely connected with Queen Victoria's decision to sell the Royal Pavilion to the Corporation of Brighton in 1846

The centre gates with carvings by John Thomas. Photograph by York and Son, c.1870–90.

The laying out of a new forecourt was put in the hands of the architect Decimus Burton (1800–1881) and the landscape designer William Andrews Nesfield (1793–1881). New cast-iron railings were made by Henry Grissell at the Regent's Canal Ironworks. The new railings were set between sculptural piers carved by John Thomas (1813–62), an immensely prolific sculptor and architect who was 'superintendent of stone-carving' on the Houses of Parliament. He later worked for Prince Albert on several specialist projects at Windsor, including the Audience Room, the Print Room and the Royal Dairy. The central gates to Buckingham Palace were flanked by colossal piers surmounted by dolphins and festoons of shells, ornamented on the outside with royal ciphers, two subsidiary piers with the lion and unicorn (supporters of the royal arms) and relief carvings of the coronation regalia. Thomas supplied twenty-six lesser piers, some of which were to carry lamp standards. When in 1913 the forecourt railings were once again rearranged, Thomas's central piers were moved to what became the

North Centre Gate, and replicated (with the substitution of King Edward VII's cipher for Queen Victoria's) at the southern end.

An inevitable consequence of the insertion of the new wing was the removal of the Marble Arch, which though it remained *in situ* during the construction of Blore's façade was clearly completely at odds with it. The task of moving the arch was entrusted to Thomas Cubitt, who installed it at Cumberland Gate on the north-eastern edge of Hyde Park.

The construction of the new wing was closely connected with Queen Victoria's decision to sell the Royal Pavilion to the Corporation of Brighton in 1846. In that year the Queen and Prince Albert had completed the family pavilion of their new seaside home at Osborne, which offered a far greater degree of privacy than Brighton. The sale was finally concluded by Act of Parliament in 1850, and the proceeds (£53,000) were directed towards the new wing of Buckingham Palace. The Board of Works further insisted that the fixtures and fittings removed from Brighton, including chimneypieces, panelling, light fittings and grates, should be incorporated in the interior. Although this instance of 'royal recycling' was intended as an economy measure, it seems in fact to have been more expensive than commissioning new fittings. The overall cost of the new wing was £95,500.

Exotic as they were, it is worth remembering that the main ingredients of the reused Brighton interiors had been designed for Brighton by John Nash only a few years before his work on Buckingham Palace. The redecoration of the original state rooms of the Palace, which Prince Albert had begun before the new east wing was built, was in some ways far more radical. The Prince was a serious student of Italian Renaissance art, and when travelling in Italy in 1839 he had met Ludwig Gruner.

Their work at the Palace began with the redecoration of the Grand Staircase which, following the failure of Joseph Browne's scagliola panels, had been painted a uniform pale ochre shade. In 1846 it was repainted by Charles Moxon in a complex polychrome scheme that can best be seen in Eugène Lami's watercolour of guests arriving at a ball in 1848 (see page 57). The walls were divided into rectangular and diamond-shaped panels, and Stothard's friezes were given brightly coloured marbled backgrounds. Above, the four spandrels of the dome were painted with figures of

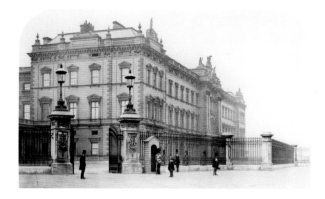

The new East Front designed by Edward Blore, photographed by Roger Fenton in c.1854.

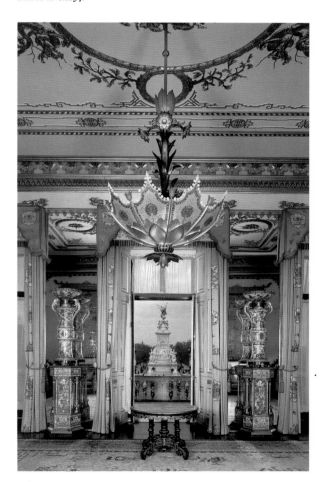

The Centre Room in Blore's east wing was fitted out with decorations from Brighton Pavilion.

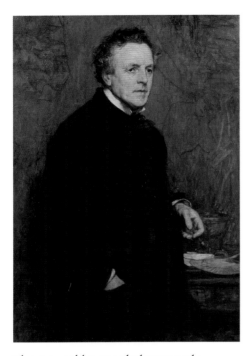

The painter and decorator Charles Moxon, who undertook the decoration of the new Ballroom and the adjoining rooms to Gruner's designs. Moxon had previously worked under Gruner's direction for Prince Albert at Osborne on the Isle of Wight. He is said to have made heavy losses on the work at the Palace. Painting by W.Q. Orchardson, 1875.

Morning, *Evening*, *Noon* and *Night* amid floral garlands against a gold background. This was part of Prince Albert's wider interest in the introduction of fresco painting in modern interiors. In 1843 he had collaborated with Gruner in commissioning William Dyce, Daniel Maclise and Charles Eastlake to decorate the interior of a specially built pavilion in the garden of Buckingham Palace, as a preliminary experiment for the great project of decorating the interior of the new Houses of Parliament. In 1841 Prince Albert had been appointed Chairman of the Royal Commission on the decorations of the new Parliament. The artist chosen for the paintings on the Grand Staircase, Henry James Townsend, was one of the winners of the competition for the work at the Palace of Westminster.

The second part of Queen Victoria's request of 1845, for a suitably large room for grand entertainments, was finally fulfilled in 1851, when Thomas Cubitt submitted designs to the Commissioners of Works for a new ballroom on the south side of the Palace. Although the intention seems to have been for Cubitt to act as both architect and builder, James Pennethorne (1801–71) was subsequently appointed as architect, completing his own designs in 1852. Pennethorne had studied in Paris and Rome in the early years of the century and had served his apprenticeship in Nash's office during the original construction of the Palace. He was responsible for many of the most prominent public buildings in London, such as the Public Record Office in Chancery Lane, the Inland Revenue offices at Somerset House, and the façade of Burlington House in Piccadilly.

A secondary requirement (reflected in the original name 'Ball and Concert Room') was for a room in which the Queen and Prince Albert could hold large-scale musical performances. Both were competent and devoted musicians, and more than one hundred large-scale orchestral concerts were given at the Palace during Queen Victoria's reign.

Pennethorne designed two very large new rooms, the Ball and Concert Room and Ball Supper Room, linked by galleries to Nash's state apartments at their southern end. Beneath them, enclosed by a rusticated façade, Pennethorne planned new fully equipped kitchens and the associated 'offices'. For the exterior of the Ballroom and Supper Room, he returned to Nash's French-inspired Neoclassical language, using Bath stone with sculptural enrichments (such as Flaxman's scrolling frieze) in Coade stone. For the interiors, Prince Albert called once again on Ludwig

Gruner, who travelled to Rome to make accurate records of the Renaissance mural paintings that would inspire the treatment of the new rooms. In Rome he met Nicola Consoni (1814–84), who was working on the decorations of the new church of S. Paolo fuori le Mura, and whom he persuaded to travel to England to undertake the work at the Palace in collaboration with Charles Moxon. Prince Albert's particular interest in the work of Raphael, manifested at this time by his project to assemble a comprehensive pictorial archive of the artist's work at Windsor (eventually comprising 5,000 images), provided the basis for Gruner's scheme. The ceiling and frieze of the Ball and Concert Room were ornamented with arabesques derived from Raphael's Vatican *stanze* and on the upper walls the spaces between the windows were painted with twelve dancing female figures representing the Hours, again derived from Raphael. The lower parts of the walls were hung with crimson silk woven with the national flowers. The decoration of the Supper Room was no less sumptuous or striking, conceived as the interior of an exotic tent.

Ludwig Gruner (1801–62), Prince Albert's adviser on the decoration of Buckingham Palace, photographed in 1860.

LEFT: *One of the interiors of the Pavilion built by Prince Albert in the grounds of the Palace in 1843.*

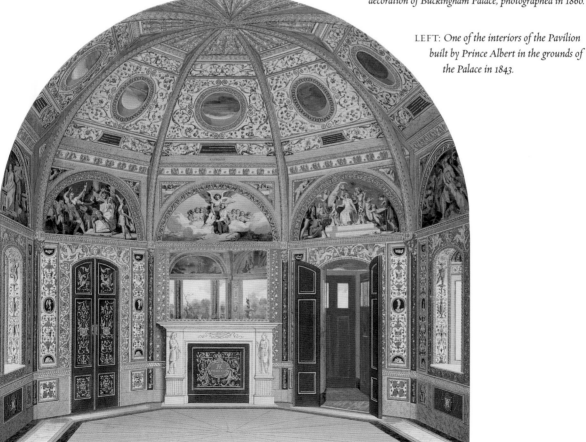

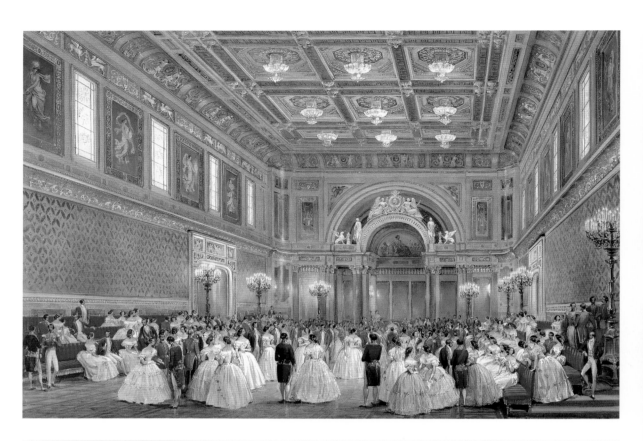

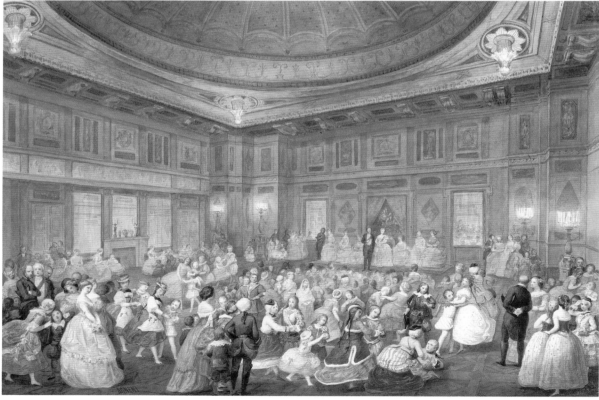

Queen Alexandra was said to regard the Victorian scheme in the Ballroom as 'simply perfection'

ABOVE LEFT:
The Ballroom in use soon after its completion. Watercolour by Louis Haghe, 1856. When the new Ballroom was completed Queen Victoria described it to her uncle, King Leopold I of the Belgians, as 'truly magnificent and truly convenient'.

ABOVE: *Design for the remodelling of the Ballroom by Frank T. Verity (1864–1937), c.1904.*

BELOW LEFT:
The Fancy Ball held in the Ball Supper Room on 7 April 1859 for the sixth birthday of Prince Leopold. Watercolour by Eugenio Agneni.

VICTORIAN SMOG

Count Helmuth von Moltke, while in London in the suite of Prince Frederick William of Prussia attending the Princess Royal's wedding in 1858, wrote to his wife: 'Even in Buckingham Palace there was yesterday a thick fog consisting chiefly of coal smoke. Pictures, gold frames, and embroidered work, must suffer very severely under it.' For this reason many of the paintings in the Palace were glazed, but the decorations continued to grow blacker as the century progressed.

As described in the architectural magazine *The Builder*, the central dome was:

> ...a blue velarium, sown with golden stars, and bordered by arabesques... it is painted as if the sky was seen beyond, between the cords which tie it down at the foot... The walls of the upper part of the room are divided into panels alternately painted with arabesques in colour, on a red ground, and the royal arms in chiaroscuro on a gold ground.

For the north and south sides of the room, the sculptor John Gibson devised low-relief plaster friezes based on Raphael's *Cupid and Psyche*, which were executed by William Theed.

As first completed, the Ballroom and Supper Room were the most sophisticated English examples of the style of decoration perfected by Cornelius in Munich, and by Leo von Klenze for the palaces of St Petersburg. They placed Buckingham Palace in the avant-garde of decoration in England, leading the critic of *The Builder* to designate the Palace as 'Headquarters of Taste'.

These decorations, and the earlier schemes carried out for Prince Albert, survived for the remainder of the century. After the Prince's untimely death in 1861, Queen Victoria declared that nothing for which he had been responsible should be touched. During her long absences from the Palace in the ensuing forty years, whether at Osborne, Windsor or Balmoral, the effects of London's atmosphere – heavily laden with coal dust and smoke – infiltrated every corner of the building.

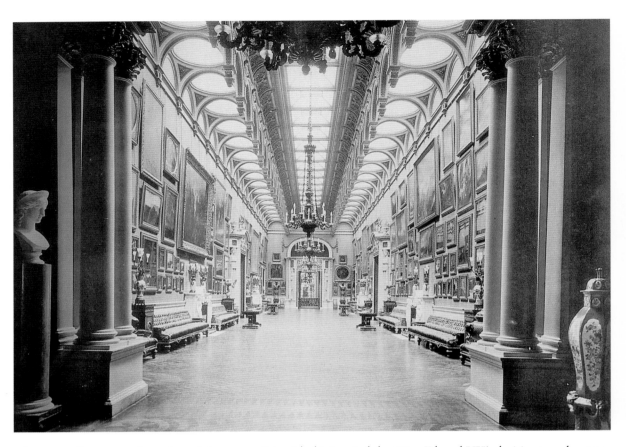

The Picture Gallery in 1910. The circular rooflights to the sides survive from Nash's design. The central square lights were introduced by Edward Blore.

It is with this in mind that King Edward VII's decision to redecorate following his accession in 1901 must be understood.

In the Grand Entrance, Marble Hall and Grand Staircase, C.H. Bessant of the firm of Bertram & Son replaced the Victorian polychrome decorations with the all-pervading white-and-gold scheme that survives today. The Ballroom and Supper Room presented greater challenges, not least that Queen Alexandra was said to regard the Victorian scheme in the Ballroom as 'simply perfection'. It seems that the King was first shown proposals for the remodelling of the Ballroom in 1901 by Frank T. Verity, the official architect of the Lord Chamberlain's Office, whose recent design for the Imperial Theatre, Westminster, built for Lily Langtry in 1901, had caught the King's attention. At the time of the *entente cordiale* it was natural that King Edward VII should choose someone whose command of the latest Louis XVI-revival style had been acquired at the École des Beaux-Arts in Paris.

But any work of a decorative nature was postponed until more pressing improvements had been made to the heating and ventilation systems of both the Ballroom and Supper Room. When

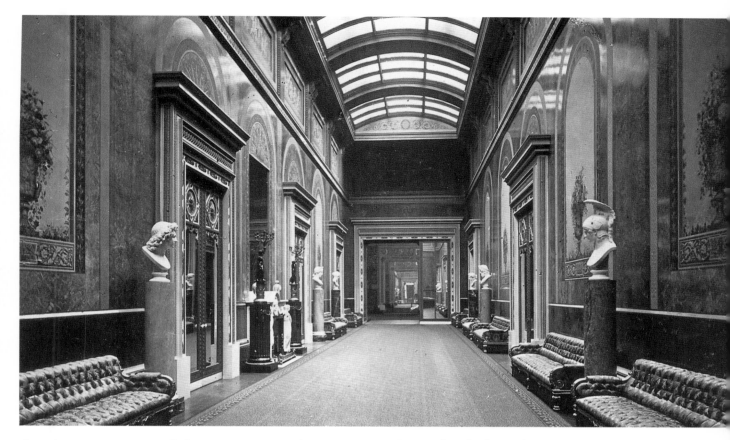

The East Gallery when first completed. The walls were painted by Moxon with arcading and vases of flowers.

the redecoration was eventually begun in 1906–7, tenders were invited from the decorating firms of White Allom and Jackson & Co. without further reference to the architect. The new design for the Ballroom, which seems to have been inspired by the recent remodelling of the enormous *Weisser Saal* in the Imperial Castle at Berlin, entailed refacing the walls with a new skin, articulated by an order of giant pilasters, and with garlanded *oeil-de-boeuf* windows in place of Pennethorne's clerestory. The central features of the end walls, the organ and the arch enclosing the throne, remained as Pennethorne had left them, but largely repainted in the ubiquitous white and gold. A similar simplifying operation was undertaken in the Ball Supper Room, with the removal of Theed's friezes and the eradication of the colourful paintwork. Meanwhile Charles Moxon's airy *trompe-l'oeil* arcades in the East or Promenade Gallery were covered with silk hangings, leaving only Consoni's grisaille paintings in the frieze as a reminder of the original scheme.

If, in carrying out these extensive works to the interior, King Edward might have seemed to be acting somewhat hastily to erase his parents' very considerable contributions to the appearance of the Palace – a view later expressed in no uncertain terms by Queen Mary – he was

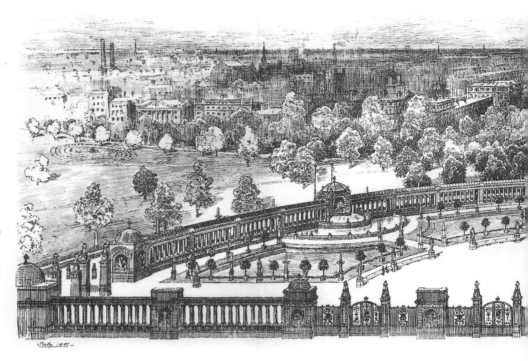

Sir Aston Webb's winning design from the competition for the Queen Victoria Memorial, as reproduced in The Builder, 1901.

quick to lend his support and patronage to the great scheme of national commemoration known as the Queen Victoria Memorial. In February 1901 a committee was established under Reginald Brett, Viscount Esher, Secretary of the Office of Works, to raise funds from all parts of the Empire towards the completion of a grand processional vista of a kind never before seen in London, but familiar from other European cities such as Paris and Vienna. It would link Trafalgar Square (originally set out by Nash and later completed by Charles Barry) with Buckingham Palace, ending with 'some great architectural and scenic change' in front of the Palace itself. The architects Ernest George, Sir Aston Webb, Sir Thomas Drew, Dr Rowland Anderson and Thomas Jackson were invited to submit designs in collaboration with a single sculptor, Thomas Brock (1847–1922). Having begun his long career as an assistant to J.H. Foley on the sculpture of the Albert Memorial in Kensington Gardens, Brock was incomparably well qualified for the task, and his collaboration with the winning architect Sir Aston Webb (1849–1930) proved inspired. The whole composition, starting with the Admiralty Arch and concluding with the central statuary group – a worthy Edwardian counterpart to the Albert Memorial in Kensington Gardens, surrounded by its great circus of gates and piers evoking the different parts of the Empire – remains London's grandest set piece of urban planning. The perimeter gates and piers – funded by contributions from Australia, Canada and South Africa – provided ceremonial entrances to Green Park and St James's Park. They were ornamented with carved animals and

RIGHT: *Aston Webb's final proposal drawing for the new front, inscribed by Lord Esher with the King's comments.*

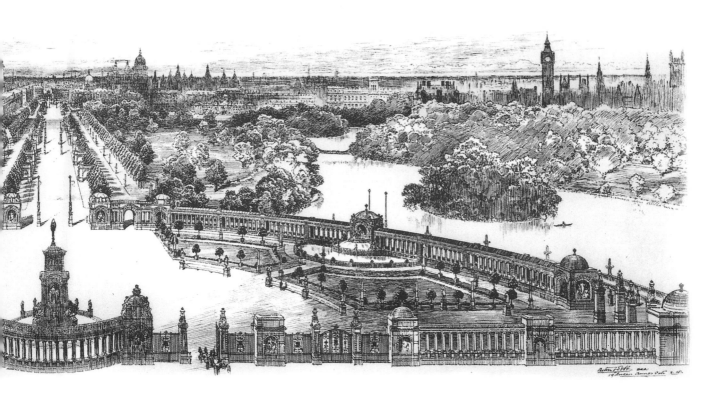

devices peculiar to each realm, executed by Derwent Wood, Henry Pegram and Alfred Drury. Brock himself undertook the sculptures of the central composition. Carrara marble was used for the centrepiece of the memorial, in which the Queen appears enthroned, and surrounded by the seas and guarded by eight colossal bronze figures, *Progress* and *Peace*, *Manufacture* and *Agriculture*, *Painting* and *Architecture*, *Shipbuilding* and *War*. Each group is accompanied by a standing lion, perhaps inspired by Landseer's recumbent beasts in Trafalgar Square. These bronzes were not yet in place by the time of the unveiling ceremony on 16 May 1911.

...a grand processional vista of a kind never before seen in London

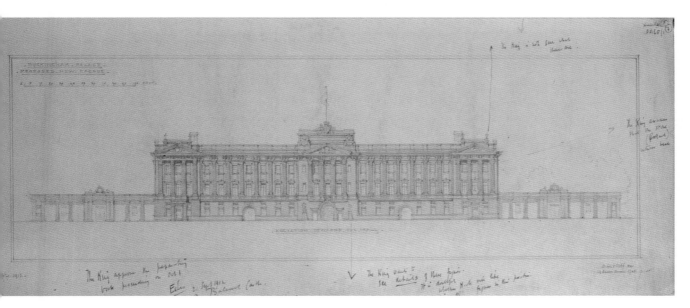

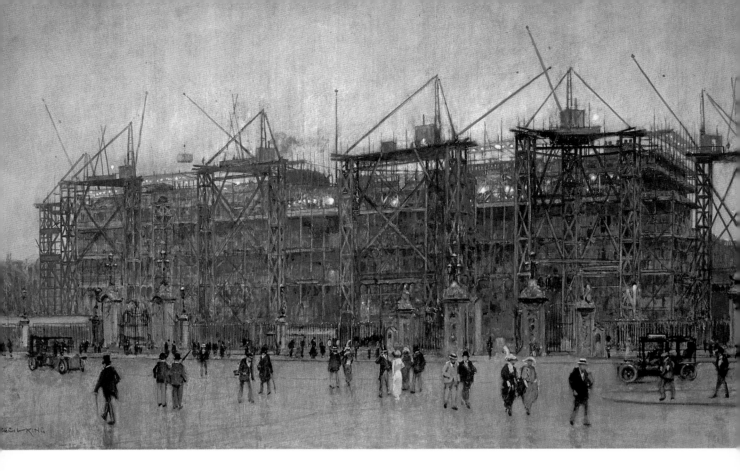

For the refacing of the East Front six scaffold towers known as 'Scots derricks' were erected at regular points along the façade. Once these were in place the fixing of the pre-cut Portland stone was accomplished in the astonishingly short period of six weeks. An average of 250 workmen were on site during the day, and a further 150 overnight. The project made full use of the new building technology developed for the rapid construction of the first skyscrapers in American cities, such as arc lighting, electric hoists, and tramways running along each level of the scaffolding. Drawing by Cecil King, 1913.

By the time the statues were finally installed in 1924, an even more significant addition had been made. Since 1866, the soft Caen stone of Edward Blore's east wing had been causing concern, and the sentries often had to shelter in their boxes from the falling fragments of masonry. The balance of opinion came down in favour of some form of refacing, removing the decayed stonework entirely. There were many who found the contrast between the gleaming white marble of the Queen Victoria Memorial sculptures and the blackened, flaking façade behind unacceptable.

That such a drastic measure as refacing could be contemplated was due to the fact that there remained a substantial balance in the Queen Victoria Memorial Fund. In June 1912, a year after the coronation of the new King George V, Webb and Brock were again instructed to prepare designs, but on a strictly limited basis. The funds would allow only a refacing, and any new design would therefore have to respect entirely the proportions and fenestration of Blore's original front.

Work in progress on the sculpture of one of the wing pediments during 1913.

36

Aston Webb was experienced in the design of institutional façades, such as those of the Britannia Royal Naval College, Dartmouth, and Imperial College in South Kensington (he was later responsible for the new front of the Victoria and Albert Museum). Nevertheless, the constraints of Blore's fenestration and the close scrutiny of his proposals by Lord Esher and the King led him through six variant stages, all of which tended towards simplification. The King's Private Secretary, Lord Stamfordham, asked Esher to ensure that the central balcony would not be curtailed, 'as it is used from time to time on occasions when the King and other members of the Royal Family wish to show themselves to the people'. Once the design was fixed in November 1912, no time was lost in carrying out the work. The main contractor, Leslie & Co., began preparing the Portland stone blocks in their yards at Fulham and Vauxhall in October, while Brock embarked on the carving of the royal arms, which measure 8 metres (25 feet) across, of the central pediment. The remaining architectural carving was undertaken by William Silver Frith (1850–1924).

The work of refacing was planned to coincide with the royal family's absence from London during the summer and early autumn of 1913. The works began on site on 5 August, and were completed on 7 November. When the scaffolding came down, what

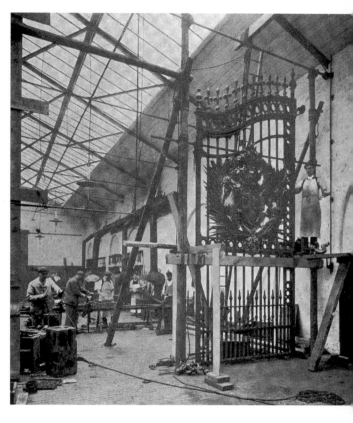

One of the centre gates under construction in the workshop of the Bromsgrove Guild, c.1905–6.

THE BROMSGROVE GUILD

The Bromsgrove Guild was founded in 1897 by a visionary craft instructor, Walter Gilbert (1871-1946), in response to widespread unemployment and poverty among those formerly dependent on the nail-making industry in and around Bromsgrove. The Guild operated until 1966 and was responsible for many distinguished and distinctive examples of iron and bronze work, as well as joinery, plasterwork, silversmithing and jewellery – including the 'Liver birds' on the twin domes of the Royal Liverpool Insurance Building in Liverpool. Walter Gilbert's name appears on the lockplate of the central gates, along with that of the Guild and the Swiss-born designer and modeller of the distinctive royal arms and lockplates, Louis Weingartner, an exceptionally gifted sculptor whose other works included the reredos of the Anglican cathedral in Liverpool. The strikingly original lockplates are surrounded by tumbling cherubs (modelled on Walter Gilbert's infant daughter) with the keyholes disguised in the initials GVRI.

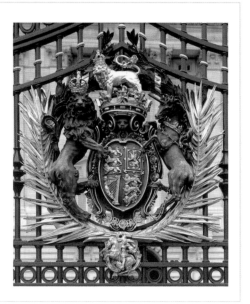

struck most people was the dramatic transition from black to white; from the engrained sooty darkness of Blore's decayed Caen stone to the hard and reflective surface of the Portland. What had been lost was Blore's picturesque skyline and incidental ornaments, but Webb's façade was soon regarded as altogether more stately and dignified, not least because it reinstated Nash's concept of temple fronts at each end of the façade with a dominant central pediment. The King laid on a supper to thank the five hundred workmen who had seen the job to completion, and in particular for their having resisted calls to join the strikes that had been threatened during the summer. Writing to Queen Mary from a shooting weekend at Elveden in Suffolk in early November, he reflected, 'I am sure the new front to B.P. looks well, but suppose it will soon get dirty.'

As part of the Queen Victoria Memorial project, the forecourt railings were rearranged to provide just two gates at the northern and southern ends. Not long afterwards it became clear that for ceremonial purposes a central gate on axis with the memorial sculpture and the balcony of the Palace was still required, and Webb designed a new, taller pair of piers for the purpose. As the final component of the memorial scheme, three magnificent pairs of bronze gates were commissioned in 1905 from the Bromsgrove Guild.

BELOW: *Proposal drawing by Frank Baines (1877–1933) for the remodelling and redecoration of the Picture Gallery, 1915. The new ceiling design finally resolved the chronic lighting problem and put an end to 25 years of rainwater leaks.*

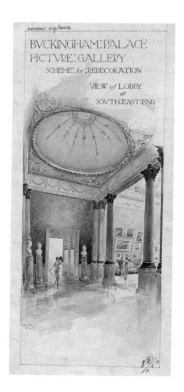

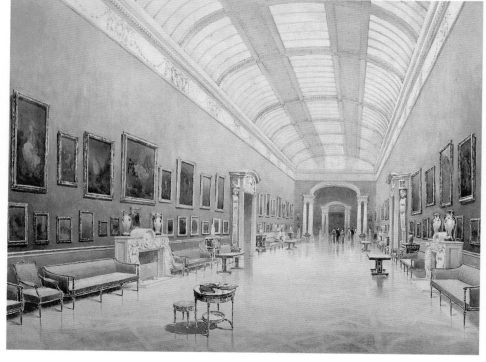

With the Queen Victoria Memorial Scheme, the Palace reached its final form. Only a year after the final completion of the East Front, the central balcony assumed an unforeseen importance when the King and Queen appeared before massed crowds on 4 August 1914, the day of the outbreak of the First World War. During the Second World War the Palace itself became a target. In April 1940 and repeatedly the following September, bombs fell on parts of the building, destroying the south-western conservatory (Queen Victoria's Private Chapel) and the columned screen at the north end of the East Front, flanking the Sovereign's Entrance, together with more than 100 metres of the forecourt railings (see page 46). These were remade by the Bromsgrove Guild, but in common with much of the rest of London, the buildings themselves could not be repaired for some years, taking their place in the order of priority for materials and labour. When it became possible to devote these resources to the rebuilding of the Chapel, the opportunity was taken to provide for the first time a space for the temporary public exhibition of changing selections from the Royal Collection. The Queen's Gallery, as it became known, was the brainchild of HRH The Duke of Edinburgh, and first opened its doors in 1962. Forty years after almost five million visitors had enjoyed 38 exhibitions, the Gallery was redeveloped and considerably enlarged to a new design by John Simpson to celebrate The Queen's Golden Jubilee.

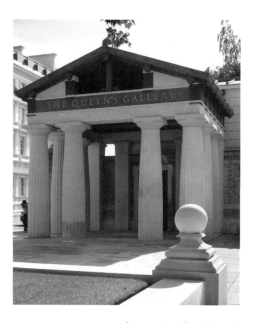

ABOVE AND BELOW: *The Queen's Gallery, designed by John Simpson and opened by Her Majesty The Queen in May 2002.*

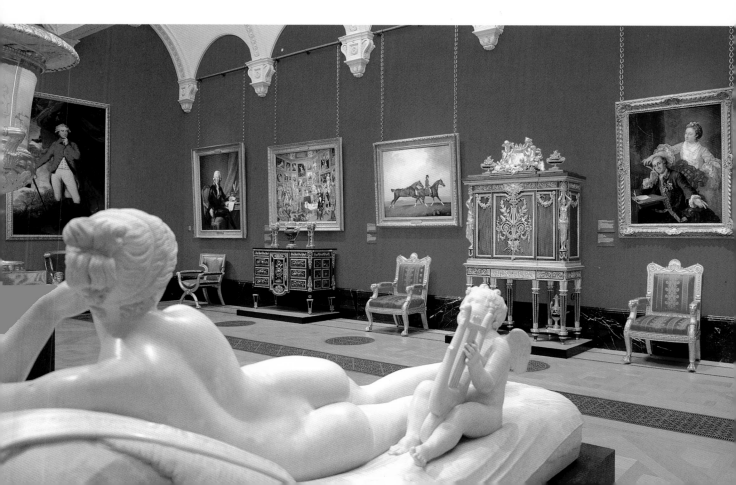

2 The Occupants of Buckingham Palace

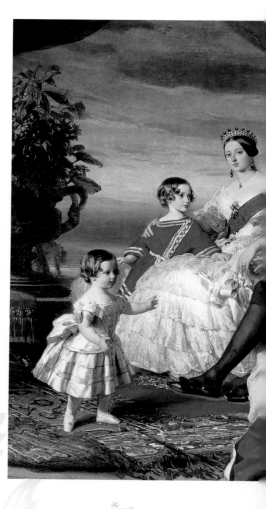

Queen Victoria (1837–1901) and Prince Albert (1840–1861)

Queen Victoria succeeded her uncle William IV at the age of only 18 on 20 June 1837. On 13 July she left her childhood home, Kensington Palace, and became the first Sovereign to rule from Buckingham Palace. Although the Palace was habitable, the fitting out and decoration of the private apartments was far from complete, and remained so until after the Queen's marriage in 1840 to her first cousin, Prince Albert of Saxe-Coburg and Gotha.

The young Queen determined to make use of the newly completed, colourful state rooms, and the regular state and private balls at the Palace became a centrepiece of the London season. In the first decades of her reign the Queen was an enthusiastic dancer, often staying up until the small hours of the morning. Grand and spectacular as all the occasions were, the conditions in the Throne Room, Picture Gallery and Blue Drawing Room were cramped, and the numerous candles gave off both heat and liberal quantities of wax, which stuck to the wigs and heavy velvet gowns of the guests. In the course of her travels in France and Germany, Queen Victoria had taken note of the far more ample and suitable accommodation that existed in continental palaces. This was the primary impulse for the construction of the new Ballroom (originally designated the Ball and Concert Room) which was added to the south side of the Palace in 1855.

To support so much new activity, a radical reform of the Royal Household was required, and in this as in so many areas, Prince Albert proved an able reformer, guided by his mentor and former physician, Baron Christian Stockmar. In the course of twenty years, Queen Victoria and Prince Albert transformed what they had taken on as a previously uninhabited and architecturally incomplete palace into the centre of an energetic, cosmopolitan court. The unceasing round of ceremonial and state occasions went

FROM *THE TIMES*,
Wednesday, 13 July 1837

'There are upwards of 300 workmen now engaged, having commenced on Monday, completing the fitting-up of Buckingham Palace. Orders have been issued that they shall finish by tonight. All the plate was removed from St James's Palace yesterday morning, as well as the whole of the kitchen apparatus. On Thursday Her Majesty will take possession of Buckingham Palace, and will dine there that day.'

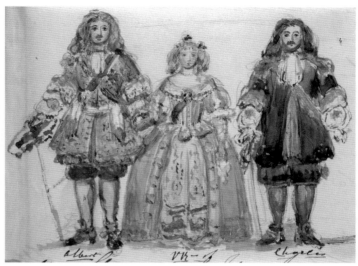

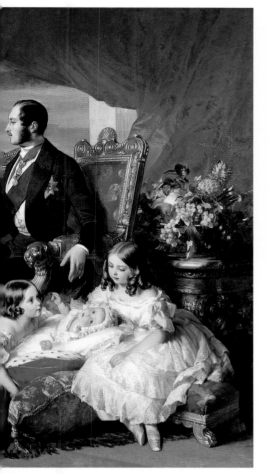

ABOVE: *Prince Albert, Queen Victoria and Charles, Prince of Leiningen (the Queen's half-brother) in costumes of the period of Charles II for the costume ball of 1851. This is Queen Victoria's own watercolour sketch from her Journal.*

LEFT: *Franz Xaver Winterhalter,* The Royal Family in 1846. *Queen Victoria, Prince Albert and their five eldest children.*

BELOW: *Late 19th-century photograph of the Ballroom prepared for a state concert.*

Programme for a concert in the Ballroom.

The concerts were given by Queen Victoria's private band of twenty-four players, supplemented by further musicians from the leading London orchestras, and by choral singers from the opera houses. Among the soloists who regularly performed here were the singers Clara Novello, Adelina Patti, Nellie Melba and Clara Butt; and the bass Luigi Lablache (Queen Victoria's singing teacher), the violinist Joseph Joachim and Queen Victoria's Welsh harpist John Thomas. The repertoire included music by Rossini, Berlioz, Mozart, Handel, and Queen Victoria and Prince Albert's favourite composer, Felix Mendelssohn.

MUSIC AT COURT

During a state ball, two or three orchestras would be disposed around the state apartments, and in 1838 – when the Austrian composer and conductor Johann Strauss the Elder conducted his orchestra at the Palace on a dozen occasions – the 19-year-old Queen was seen pointedly to remain in his room at the expense of the other performers, declaring, 'I have never heard anything so <u>beautiful</u> in my life as Strauss's band.' Strauss composed his Tribute to Queen Victoria of Great Britain in that year, including a waltz-time version of the national anthem. In the previous year, the 25-year-old Sigismund Thalberg – 'the most famous pianist in the world', as the Queen described him in her Journal – had her 'quite in ecstasies and raptures' as she listened to his playing. He was the first of a lengthy succession of musical visitors to the Palace.

Felix Mendelssohn (1809–1847) visited on five occasions between 1842 and 1847, each time playing for the royal couple and sometimes listening to or accompanying their own singing. During his last visit, in 1847, he asked the Queen if he could see the royal nurseries; the request was immediately granted, and the Queen 'in her most winning way conducted him... all the while comparing notes with him on the homely subjects that had a special attraction for both'.

Marble bust by Ernst Rietschel, c.1848.

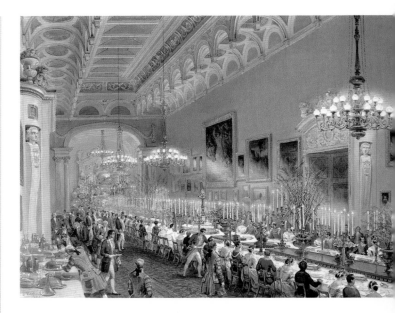

The Picture Gallery in use for a banquet in honour of the christening of Prince Leopold in 1858. Watercolour by Louis Haghe, 1858.

hand in hand in those years with the complete internal redecoration of the Palace in an advanced Renaissance revival style, and the introduction of new technology. In 1856 the future Prime Minister Benjamin Disraeli spoke for many when he declared after first seeing Pennethorne's new Ballroom in action, 'I had never seen before in England anything which realised my idea of a splendid court.' Many of the ingredients of this new court were continental in inspiration, and specifically German, for example the choice of Ludwig Gruner as the overseer of the new decorations. In the summer of 1842 the Prussian court goldsmith J.G. Hossauer was surprised on leaving the Palace, having presented some models to Prince Albert, to encounter his compatriot Felix Mendelssohn crossing the forecourt in the other direction.

Although the series of state concerts continued with little interruption in the Ballroom after Prince Albert's untimely death in 1861, all other entertainments ceased. As the Queen spent lengthy periods at Windsor, Osborne or Balmoral, the Palace fell into a long period of inactivity. The brightly coloured interiors gradually darkened as the century, and the reign, drew to a close.

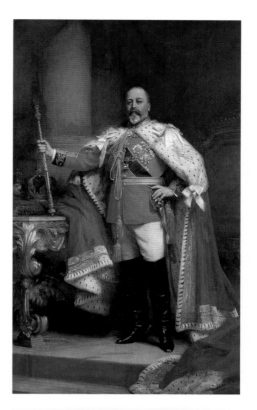

King Edward VII and Queen Alexandra (1901–1910)

Long in waiting as Prince of Wales, the new King Edward VII moved into Buckingham Palace a short time after his mother's death in January 1901 and with an impact that was later described as like that of a Viennese hussar bursting suddenly into an English vicarage. Declaring with a characteristic roll of his 'r's, 'I don't know much about *arrt*, but I think I know something about *arr*angement', he set about the complete redecoration of the interior in a universal white-and-gold finish. The Surveyor of The King's Works of Art, Lionel Cust, meanwhile saw to the overhaul of the contents, and improvements were put in hand to the heating, ventilation and electric lighting. By March 1902, court life was resumed. There were some reforms, such as the King's abolition of afternoon Drawing Rooms in favour of Evening Courts, which suited his routine far better and allowed more grandeur of costume, even if still within strict confines laid down by the Lord Chamberlain. It was decided that the 60-year-old King should preside at Evening Courts seated on the throne, and a new dais and canopy were set up in the Ballroom for this purpose. The long series of state concerts that had taken place in the Ballroom since its completion in 1856 now came to an end. King Edward had become accustomed to the more cosmopolitan allure of the dance bands employed by his friends such as Alfred de Rothschild. He abolished the King's Private Band and invited outside ensembles, such as Herr Iff's Orchestra and Gottlieb's Orchestra, to perform during Evening Courts and at balls.

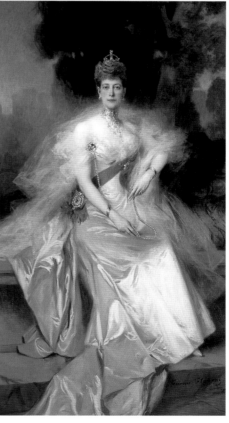

ABOVE: *State portrait of King Edward VII by Sir Samuel Luke Fildes, 1902.*

RIGHT: *Portrait of Queen Alexandra by François Flameng, 1908.*

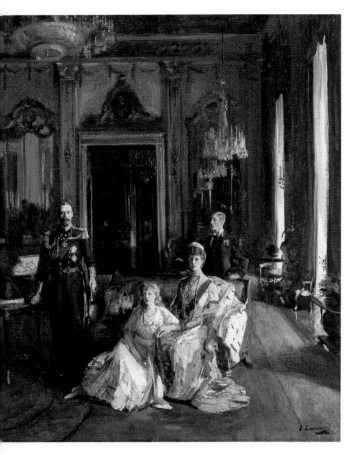

Sketch by Sir John Lavery for his large group portrait of the family of King George V in the White Drawing Room, 1913.

King George V and Queen Mary (1911–1936)

For Queen Mary, Buckingham Palace, which she had left on the day of her marriage to the Duke of York in 1893, was a place of fond memories, but the move from Marlborough House, which she and her husband had occupied during the reign of King Edward VII, was no less daunting. She wrote soon after moving in to the Palace, 'Everything here is so straggly, such distances and so fatiguing.' She had been anxious when her father-in-law had launched so precipitously on redecoration, recalling later that 'many things were changed here much too quickly by our predecessors', adding that 'it is always best to do such things very *piano* and with much reflection'. Nevertheless, at Buckingham Palace Queen Mary was able to indulge her 'one great hobby', the researching and arranging of the Royal Collection. She was a voracious learner and receptive to advice, calling on the curators of the Victoria and Albert Museum to arrange her private rooms and some of the ground-floor apartments with works of art of a specific period or type.

During the early years of King George V's reign, the Palace was often the backdrop against which great issues were played out. In July 1914 the King convened a conference in an attempt to bring together the parties involved in deciding on the boundaries of what became the province of Northern Ireland. In December of that year, the long-running campaign for Women's Suffrage was given greater prominence by the arrest of its leader Emmeline Pankhurst outside the Palace gates as she sought to deliver a petition to the King.

Twenty years later, in 1935, the King celebrated his Silver Jubilee with an exultant nation. Commemorative events and initiatives were held throughout the country, for which the Palace once again provided a focus.

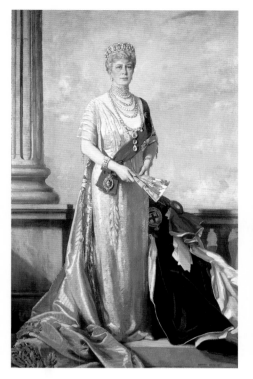

Portrait of Queen Mary
by Richard Jack, 1927.

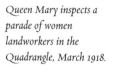

Queen Mary inspects a
parade of women
landworkers in the
Quadrangle, March 1918.

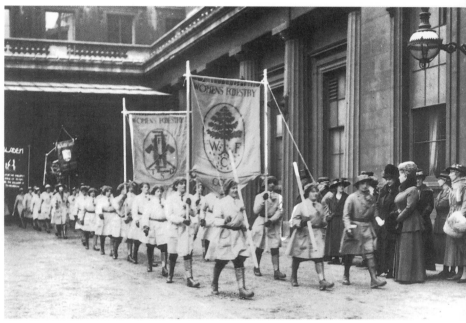

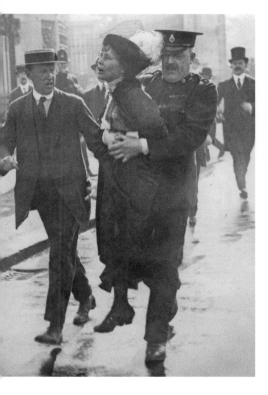

Mrs Emmeline Pankhurst
is arrested by police
outside the Palace railings
in May 1914 in an attempt
to deliver a petition on
women's suffrage to
King George V.

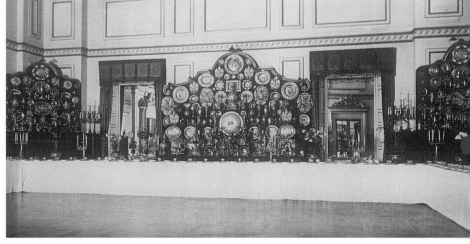

The Ball Supper Room
arranged with a display of
plate for a state banquet
in honour of the French
president in 1913.

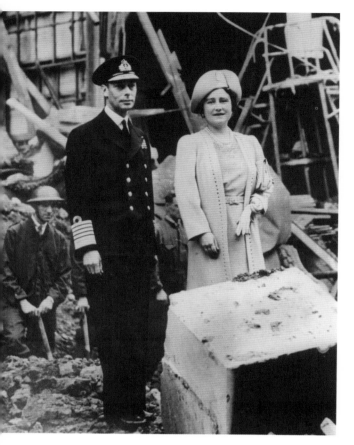

King George VI and Queen Elizabeth (1936—1952)

The reign of King George VI was dominated by the Second World War, for the duration of which the normal life of the Palace was suspended. The King and Queen's decision to remain in residence during the intense bombing of London in 1940 was an inspiration to the country. In the early months of 1940, Queen Elizabeth gave several sittings to the painter Augustus John in the Yellow Drawing Room on the East Front, but these were suspended because – as the Queen's Private Secretary noted – the temperature in the room was 'indistinguishable to that reported in Finland'.

During Germany's night offensive on London, from early September to mid-November 1940, when London was attacked by an average of 160 bombers per night, the King and Queen left the Palace each evening for Windsor, returning in the morning. Together they ventured out repeatedly to visit bomb-damaged communities in east and south London, encouraging those who had lost their homes in the task of rebuilding.

When the European war finally ended on 8 May 1945, the King and Queen and the Princesses Elizabeth and Margaret Rose appeared on the balcony before unprecedented crowds, returning eight times during the day and evening, a scene that was repeated when hostilities finally came to an end in the Far East, on 15 August, VJ Day. As the former routine of the Palace began slowly to recover, the King broadcast his Christmas message in reassuring terms: 'This Christmas is a real homecoming to us all, a return to a world in which the homely and friendly things of life are again to be ours.'

BELOW LEFT: *Damage to the north screen of the East Front after the bombing raids of September 1940.*

ABOVE: *King George VI and Queen Elizabeth inspecting bomb damage to the private chapel, September 1940.*

BELOW RIGHT: *Queen Elizabeth with ladies of her Household making clothes and bandages for the Red Cross in the Blue Drawing Room, October 1939.*

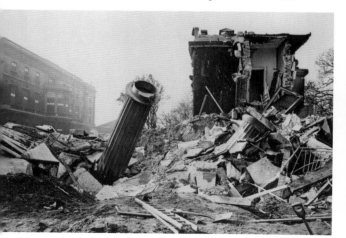

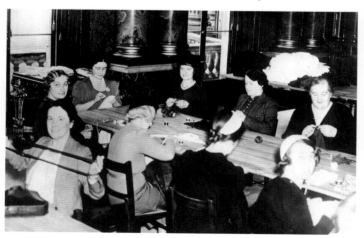

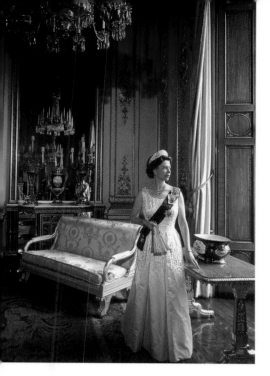

ABOVE: *Her Majesty The Queen in the White Drawing Room in 1966. Photograph by Karsh of Ottawa.*

BELOW: *The last débutante to be presented to The Queen, Miss Lovice Ullein-Reviczky, arriving at the Palace on 20 March 1958.*

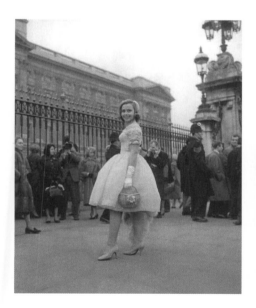

RIGHT: *Decorations in the Mall for The Queen's Coronation Procession, 2 June 1953.*

Her Majesty The Queen and HRH The Duke of Edinburgh (from 1952)

After their marriage in November 1947, The Princess Elizabeth and The Duke of Edinburgh lived at Buckingham Palace on a temporary basis in a suite of rooms that was made available for their use while Clarence House was refurbished, following its wartime use by the British Red Cross and Order of St John. In November 1948 The Prince of Wales was born at the Palace, moving with his parents to Clarence House in 1949. The sudden death of the King in February 1952 brought the new Queen and her husband to occupy Buckingham Palace on a permanent basis, which they have now done for far longer than any other royal couple.

The decisively forward-looking mood of the early years of The Queen's reign, in the wake of the Festival of Britain of 1951, and the rapid pace of social change were mirrored in the simplification of many aspects of court life. In 1958 the practice of Presentation at Court, at which débutantes were presented to The Queen at receptions in the state rooms, was discontinued. This decision was taken not because such ceremonies were outdated, but rather because the overwhelming number of

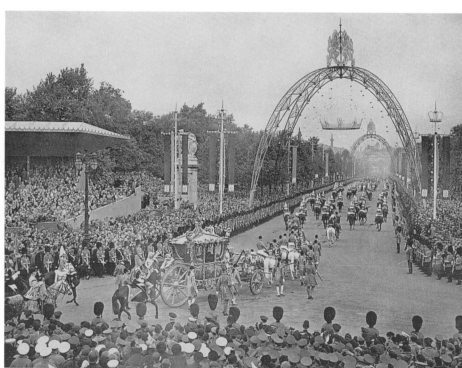

ABOVE: *President and Mrs George W. Bush at Buckingham Palace during the State Visit of 2003. The Queen, as Head of State, receives a large number of formal and informal visits during the year, from the Privy Council, foreign and British ambassadors and high commissioners, members of the clergy, and senior officers of the armed services and the civil service.*

applications meant that some form of selection – which would have been invidious – would have had to be applied.

The present reign has been characterised by the extent to which The Queen and The Duke of Edinburgh have travelled out to meet the country and the world in the course of 80 state visits, 160 overseas visits and innumerable journeys around every part of the United Kingdom. Meanwhile, well over a million people from Great Britain, the Commonwealth and the fifteen other countries of which The Queen is Head of State have attended the annual garden parties during the course of the reign.

Along with the continuing repair of damage left over from the war, essential works of modernisation have been accompanied by subtle decorative changes within the Palace. The fireplaces were converted to electricity in 1956, and the Picture Gallery, Silk Tapestry Room and State Dining Room were redecorated. In 1962, on the initiative of The Duke of Edinburgh, a new public gallery, The Queen's Gallery, was created from the ruins of the former

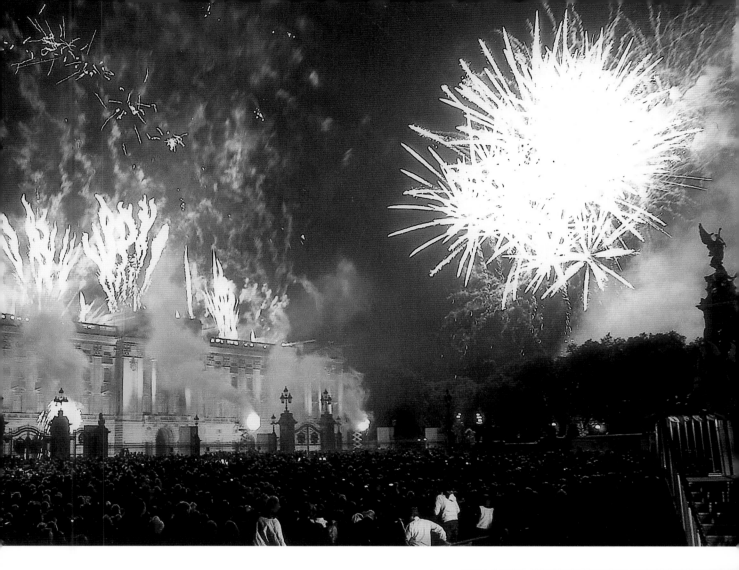

Private Chapel. The Queen's Gallery was intended to provide members of the public with opportunities to see works of art from Buckingham Palace (in addition to what was already on display at Windsor, Holyroodhouse and the unoccupied royal palaces). In 1993 The Queen decided that the Palace itself should be opened for the summer months in order to raise funds for the great task of rebuilding Windsor Castle following the disastrous fire the previous November. Following the completion of the rebuilding in 1997, revenues from the annual Summer Opening have been directed to the care and maintenance of the Royal Collection and to major capital projects, chief among them the comprehensive rebuilding and enlargement of The Queen's Gallery, completed in the Golden Jubilee Year of 2002.

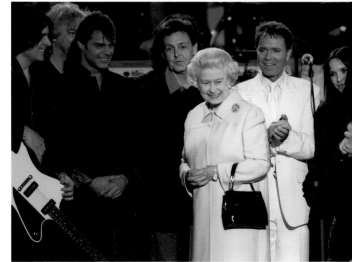

ABOVE: *Two concerts marking The Queen's Golden Jubilee were held in the garden at the beginning of June 2002 featuring classical and popular music. Each was attended by 12,000 people and concluded with fireworks.*

3 Tour of the Palace

The East Front and Forecourt

The East Front of the Palace remains exactly as it was after the extraordinarily rapid refacing operation of 1913, with a Portland stone façade designed by Sir Aston Webb, using funds left over from the Queen Victoria Memorial project. The design had to respect the fenestration of Edward Blore's original wing of 1847–50, which was of the softer, Caen stone and much blackened and decayed. The arms in the central pediment of Webb's new front were carved by Sir Thomas Brock and the remaining sculptural embellishments by W.S. Frith. The central arch is reserved for use by the Sovereign on the most important ceremonial occasions, while the two lower arches and their pedestrian side arches are in regular use. At the extreme right-hand (northern) end of the main façade is the Privy Purse Door, where those on official business with the Royal Household are admitted. The Side Door, located on the south side of the Palace, receives all deliveries and trade vehicles.

The Bath stone screens at the northern and southern ends were added by Edward Blore during his completion of the Palace in the early 1830s, largely following Nash's designs. The northern extension is merely a screen, while the southern forms the façade of the Guard Room. The railings, gates and piers are as laid out in 1906, incorporating parts of earlier arrangements. The three principal gates and the railings themselves were made by artists of the Bromsgrove Guild (see page 37). As early as 1850 when the forecourt was first enclosed by high railings, the Duke of Wellington suggested that the sentries and their boxes should be moved to new positions against the front of the Palace. In the event they remained outside the railings until 1959.

THE CHANGING OF THE GUARD

This ceremony, whereby the soldiers who have been on duty at St James's Palace and Buckingham Palace (the 'Old Guard') are relieved by the 'New Guard', takes place at 11.00 on the Forecourt. In autumn and winter the ceremony is held on alternate days. The Queen's Guard is made up from the five regiments of Foot Guards: the Grenadier, Coldstream, Scots, Irish and Welsh Guards. The ceremony has the following stages:

11.00 Both detachments of the Old Guard parade and are inspected at Buckingham Palace and St James's

11.15 The St James's Palace detachment of the Old Guard marches to Buckingham Palace with a band

11.30 The New Guard arrives at Buckingham Palace from Wellington Barracks led by a band. During the transfer of duties the band plays a selection of music

12.05 The Old Guard leaves Buckingham Palace for Wellington Barracks accompanied by the band

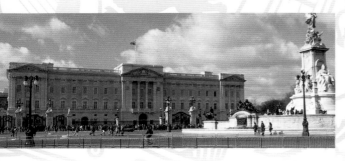

FAR LEFT: *The East Front.*
LEFT: *Dealing with the problem of pigeons on the central pediment, 1975.*

The Ambassadors' Court

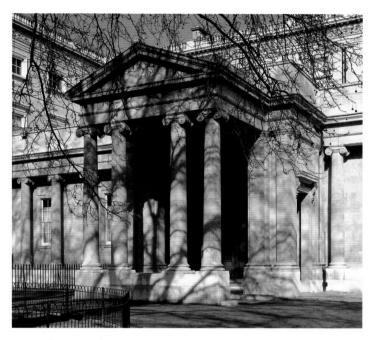

PRESENTATION AT COURT

Since the Middle Ages, access to the person of the Sovereign has been controlled by the senior official of the Royal Household, the Lord Chamberlain. The system of regular assemblies of those seeking the Lord Chamberlain's leave to be presented to the monarch dates from the reign of Queen Anne (1702–14), when afternoon Drawing Rooms were instituted at St James's Palace. These continued throughout the eighteenth and nineteenth centuries, in parallel with regular morning Levées, which took place twice weekly and were for men only. King Edward VII replaced the Drawing Rooms with Evening Courts, which remained a central part of the London social season until 1939. Dress regulations were very strictly adhered to, and these occasions provided widespread employment among dressmakers and official tailors. Presentation at court was resumed in 1947 in the form of a Presentation Garden Party, which from 1949 was held in the state apartments. During this period the parties were specifically designed for débutantes in their first London season. In 1958 it was decided that Presentation Parties should be discontinued and replaced by additional garden parties.

Ambassadors' Court

The visitor enters the Palace via the Ambassadors' Entrance, which with its Ionic portico was designed by Edward Blore during the completion of the Palace after the dismissal of Nash in 1831. As its name suggests, this entrance was reserved for foreign ambassadors to the Court of St James's and others, such as senior members of the Government and of the diplomatic or armed services, with the special privilege known as the *entrée*. The narrow passage within, called the Entrée passage, was designed for King George V and Queen Mary in 1924 by Sir Charles Allom. From here, visitors today pass via the Lower Corridor to the Grand Entrance.

Foreign diplomats and their ladies arriving at Ambassadors' Entrance for a Drawing Room, August 1868.

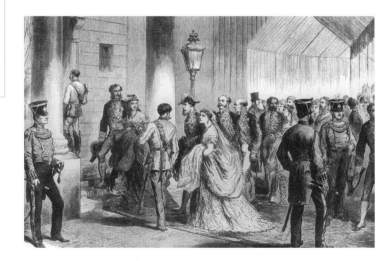

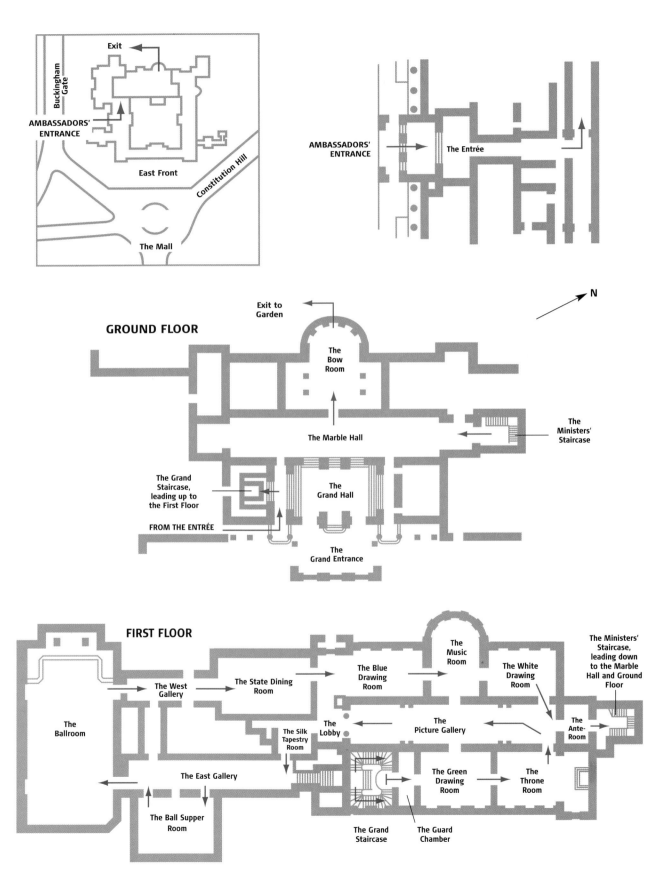

The Quadrangle

From the platform by the entrance to the state apartments, the whole Quadrangle can be seen at a glance. On the opposite side is the rear elevation of Queen Victoria's wing of 1847–50, which provided additional offices, accommodation for visitors (on the principal floor) and nurseries (on the 'chamber' floor). Before it was built, the court was open on this side, with the Marble Arch at the centre (see page 18). This wing was built in a comparatively soft French limestone which soon began to decay; it has been repeatedly painted ever since. The wings to the left and right (north and south), are part of Nash's original building and, like the main block of the Palace, are faced in Bath stone with friezes and capitals in Coade stone supplied by William Croggon in 1827. The massive Doric columns of the lower storey are of painted cast iron. The left-hand (north) wing is devoted to the offices of the Lord Chamberlain and Private Secretary's departments, with domestic accommodation above. The right-hand (south) wing contains the offices of the Master of the Household and Privy Purse departments, with further accommodation on the chamber storey. It is in the Quadrangle that carriage processions form up on ceremonial occasions such as the State Opening of Parliament. During a state visit, the mounted band of the Household Division plays here to welcome the carriages containing the visitor and their suite.

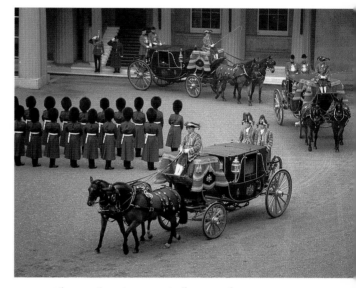

ABOVE: *The Queen's carriage procession forming in the Quadrangle for the State Opening of Parliament.*

The State Rooms

The term 'state rooms' is applied to those rooms that were designed and built as the public rooms of the Palace, in which the monarchs receive, reward and entertain their subjects and visiting dignitaries. The state rooms occupy the heart of the Palace, and most of what lies beyond them is devoted to subsidiary, service functions. In some ways this distinction is comparable to the division of a theatre into 'front and back of house' areas, and the state rooms can be likened to stages, which are provided with different settings as each occasion demands, often changing two or three times a day, as an evening performance follows a matinée. It is

therefore fitting that they were planned and designed by John Nash, whose great expertise was in the design of theatres. The Grand Staircase and Throne Room in particular are strongly reminiscent of this form of architecture.

The visit also takes in the two gigantic rooms added to the Palace for Queen Victoria, the Ballroom and the Ball Supper Room, and the spacious corridors that connect them to Nash's rooms. These were designed by Sir James Pennethorne, who was able to adapt Nash's style with ease to modern taste, incorporating the requirements of both the Queen and Prince Albert.

A second, complementary purpose of the state rooms is for the display of some of the most outstanding works of art in the Royal Collection, which provide a permanent and magnificent backdrop to the events that take place here. This has always been the primary function of the Collection, and as well as allowing for the display of pictures and furniture throughout the apartments, Nash included two purpose-built galleries, for paintings and sculpture, at the very heart of the Palace, one above the other. The contents and fittings of these galleries and of the other state rooms were intended to be drawn initially from Carlton House, George IV's London residence as Prince of Wales and Prince Regent, which was demolished at the same time as Buckingham Palace was being built.

The Grand Entrance and Grand Hall

The principal entry to the Palace via the *porte-cochère* or covered carriage entrance, the Grand Entrance forms the lower half of the two-storey portico designed by Nash at the centre of the building. It is here that ambassadors arrive in carriages several times a week, accompanied by the Marshal of the Diplomatic Corps for audiences with The Queen on taking up or relinquishing their posts in London. The Queen's guests arrive by this entrance for garden parties or evening receptions, and it is also in the Grand Hall that The Queen welcomes heads of state and presents the senior members of her Household on the first

'MARBLED HALLS'

In total, 104 columns were deployed in the Grand Hall and in the adjoining Marble Hall. Each was formed of a single block of marble quarried at Ravaccione near Carrara in Tuscany under the supervision of the mason Joseph Browne, who spent a year at the quarry from October 1825 specifically to procure marble for the columns, floors and stairs, amounting in all to 2,022 tons. The *Evening Standard* of 26 September 1829 reported the arrival of one particularly large block, weighing 24 tons, which was hauled to the Palace from the wharf at Millbank by a team of seventeen horses. A further 338 tons of marble were procured by Browne from merchants in London. Here and in the Marble Hall, Browne also provided coloured marbles for the inlaid borders to the floors. The metal capitals for the columns were supplied by Samuel Parker (see page 19).

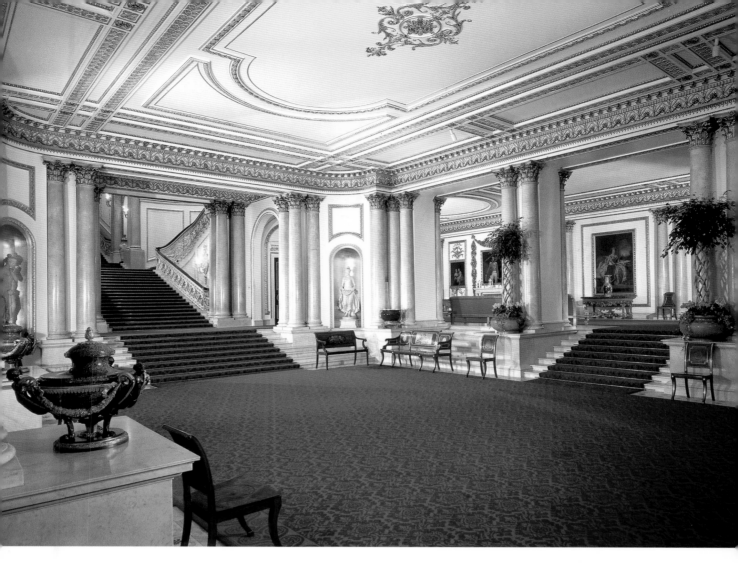

day of a state visit. On these occasions the scene is enlivened by superb floral arrangements; the scarlet cloaks, gold livery and top hats of the footmen and state porters; and the burnished steel breastplates and plumed helmets of The Queen's Bodyguard.

The Grand Hall occupies much the same area as the entrance hall of the former Buckingham House, but Nash created the impression of a far larger and more interesting space by the use of marble columns interspersed with flights of steps, enabling longer views on three sides of the room.

The decoration of this room and the other main circulation spaces conforms to the white, red and gold scheme introduced by King Edward VII soon after his accession in 1901. When first completed, the room was made more colourful by the use of scagliola, a composite material capable of being polished to imitate marble, in the framed panels above the gilded niches at each corner. Like the marble for the columns, this was supplied by Joseph Browne, but it soon began to crack and as early as 1834 the panels had to be painted over. The

ABOVE: *Detail of one of the state room doors. The design and the use of gilding contribute to the exuberant character of Nash's interiors at Buckingham Palace.*

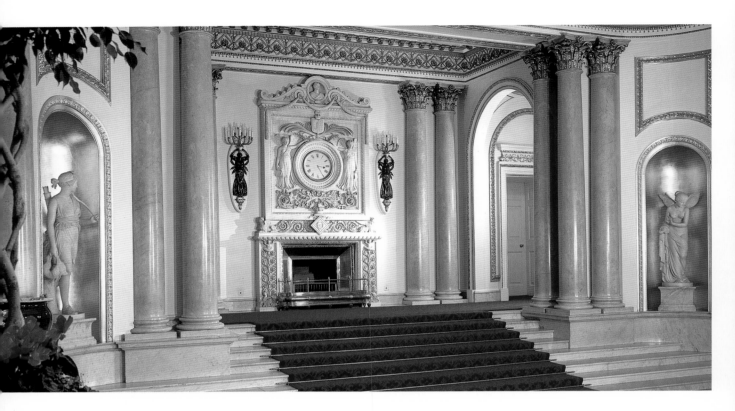

The most expensive single element of the Grand Hall was the chimneypiece, carved by Joseph Theakston, a sculptor who spent most of his career in the studios of his more famous contemporaries such as John Flaxman, E.H. Baily and Francis Chantrey. It cost £1,000 and its design was copied by Nash from a chimneypiece installed at the Tuileries palace in Paris by the imperial architects Percier and Fontaine, whose work was an important influence on Nash's designs. In the original design the bust in the recess above the clockface represents Zeus, but here at Buckingham Palace it is George IV who occupies this exalted position.

marble statues in the niches themselves were also introduced by King Edward VII, who had them brought from Osborne, his parents' house on the Isle of Wight, after it had been presented to the nation in 1902. All four of the statues were commissioned by Queen Victoria or Prince Albert from artists working in Rome.

Sculpture

Richard James Wyatt (1795–1850), *Nymph of Diana carrying a hare*, c.1850; commissioned by Queen Victoria as a present for Prince Albert. Completed by John Gibson and Benjamin Edward Spence after Wyatt's death

Gustav Eduard Wolf von Hoyer (1806–73), *Psyche with a lamp*, 1851

Pietro Tenerani (1798–1869), *Flora*, 1848

William Theed the Younger (1804–91), *Psyche lamenting the loss of Cupid*, 1847

Pair of French granite urns with patinated- and gilt-bronze mounts, purchased by George IV for Windsor Castle in 1828

Furniture

Set of mahogany hall chairs and benches painted with the Prince of Wales's feathers, made by Elward, Marsh & Tatham for the Entrance Hall at the Royal Pavilion, Brighton, 1802

Set of partly gilt mahogany hall chairs made for the Entrance Hall at Carlton House, c.1790, overpainted with Queen Victoria's cipher

Porcelain

Set of four Spode porcelain cisterns with gilt-bronze mounts attributed to Benjamin Lewis Vulliamy, c.1820

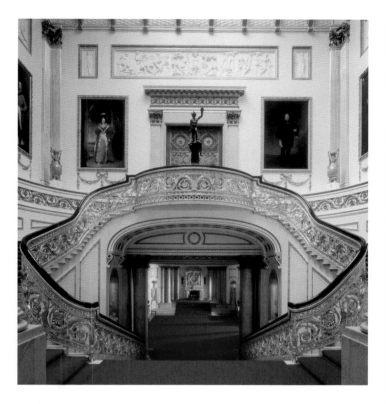

The Grand Staircase

When compared with those of the many aristocratic town houses built in London at around the same time, the staircase at Buckingham Palace occupies a notably confined space. But this allowed Nash to place more emphasis on the vertical dimension, and to draw on his experience of London theatres, where space in front of the auditorium was usually at a premium. The robust scrolls of the magnificent gilt-bronze balustrade, supplied by Samuel Parker in 1828–9 at a cost of £3,900, are echoed in the gilt plaster around the walls. The transition from the comparative darkness of the Grand Hall to the bright daylight of the staircase contributes towards the same end, imparting a sense of excitement and expectation so that the visitor, whether on a tour of the state rooms or arriving in full evening dress for a grand entertainment, reaches the top in a suitable frame of mind. From the landing there appear on all sides plaster reliefs, with playful groups of *amorini* in the curved lunettes, and friezes below representing the Four Seasons. These were designed by Thomas Stothard, a prolific artist whose work encompassed oil painting, theatrical design and above all book illustration. The task of executing the reliefs was assigned to his son, the medallist A.J. Stothard – not uncontroversially, given the number of more experienced plasterers available in London at the

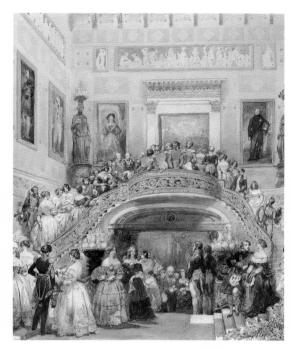

Eugène Lami, State Ball at Buckingham Palace,
5 July 1848

THE GRAND STAIRCASE
AS IT WAS

As in the Grand Hall, Joseph Browne's scagliola panels originally made the Staircase more colourful. In 1846 Prince Albert instituted a new polychrome scheme, which can clearly be seen in Eugène Lami's splendid view of the arrivals at the State Ball of 5 July 1848, but this in its turn was effaced by King Edward VII's campaign of 1902.

The Grand Staircase is lit by a shallow dome consisting of 40 panes of engraved glass.

time, notably Francis Bernasconi (d.1841), who was responsible for the lunette groups. Soon after their completion the King remarked that Thomas Stothard had 'lost none of his sprightliness' for a man over 70. The stairs are lit by a shallow dome of glass which was engraved and etched by the firm of Wainwright.

Queen Victoria fitted into the walls around the upper part of the stairs the series of full-length portraits of members of her immediate family, including her grandparents, George III and Queen Charlotte, her parents the Duke and Duchess of Kent, and her predecessor on the throne, her uncle William IV, and his wife Queen Adelaide. Queen Victoria was fond of such arrangements, and here the portraits served almost as a perpetual 'receiving line', so that whoever climbed the staircase was simultaneously introduced to her family.

When the Palace was first completed, the run of stairs leading straight on from the Grand Hall provided a secondary means of access to the state rooms via the Silk Tapestry Room. In 1855 it assumed a new importance as part of the route to the new Ballroom, to which it was connected by the Promenade Gallery (now known as the East Gallery).

Sculpture

Richard James Wyatt (1795–1850), *The Huntress*, 1850; commissioned by Queen Victoria as a birthday present for Prince Albert

Jean Geefs (1825–60), *Love and Malice*, 1859; purchased by Queen Victoria as a birthday present for Prince Albert in 1859

After Benvenuto Cellini (1500–70), *Perseus*; a 19th-century bronze reduction of the famous statue made for the Loggia dei Lanzi in Florence. Perhaps acquired by Queen Victoria's eldest daughter Victoria, later Empress Frederick of Germany

Porcelain

Four 18th-century (*Qianlong*) Chinese porcelain vases with early 19th-century English or French gilt-bronze mounts; purchased by George IV, probably from the dealer Robert Fogg in 1823

Two large 18th-century Chinese porcelain *famille rose* covered baluster vases

Pictures

(clockwise from the right of the door at the top of the stairs)

Sir Thomas Lawrence (1769–1830), *William, Duke of Clarence* (1765–1837, later William IV), 1827

Sir Thomas Lawrence (1769–1830), *Prince George of Cumberland* (1819–78, later George V of Hanover), aged 9, 1828

George Dawe (1781–1829), *Princess Charlotte of Wales* (1796–1817), 1817; the only child of George IV and Queen Caroline, married in 1817 to Prince Leopold

George Dawe (1781–1829), *Prince Leopold of Saxe-Coburg-Saalfeld* (1790–1865, later Leopold I of the Belgians), 1817; uncle to both Queen Victoria and Prince Albert

Sir William Beechey (1753–1839), *Queen Charlotte* (1744–1818), 1796; the view in the backgound is of Frogmore House in the grounds of Windsor Castle

Sir William Beechey (1753–1839), *George III*, 1799–1800

Sir George Hayter (1792–1871), *Victoria, Duchess of Kent* (1786–1861), 1835; Queen Victoria's mother

Sir David Wilkie (1785–1841), *Augustus, Duke of Sussex* (1773–1843), 1833, sixth son of George III

George Dawe (1781–1829), *Edward, Duke of Kent* (1767–1820), 1818; Queen Victoria's father, depicted as Governor of Gibraltar

Sir Martin Archer Shee (1769–1850), *Queen Adelaide* (1792–1849). 1836; consort of William IV

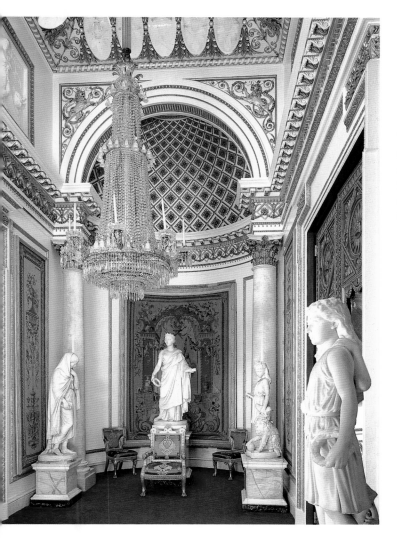

The Guard Chamber. At Buckingham Palace this room is more symbolic than useful, but though small, it is one of Nash's most successful spaces at the Palace. With its apsed ends, Carrara marble columns and richly decorated plaster ceiling by Bernasconi it forms an architectural overture to the glories to come.

The Guard Chamber

At the top of the stairs, the first of many pairs of glazed mahogany doors leads to a small room originally designated 'Ante-Room' but since known as the Guard Chamber. Nash's exuberant design for the doors, ornamented with the motif of a crown in a sunburst and with dozens of gilt metal fleurs-de-lis supplied by Parker at a cost of 7d (about 3p) each, was used throughout the state rooms and perpetuated by Pennethorne for his new rooms of the 1850s, when the varied use of plain or mirrored glass was exploited so as to create apparently infinite vistas.

In Baroque palaces of the late seventeenth century, such as Hampton Court or Charles II's Windsor, a guard chamber was invariably to be found at the top of the stairs, providing a secure barrier to the

Marble statue of the 18-year-old Queen Victoria by John Gibson, 1847.

59

A FIRST IMPRESSION

When Queen Victoria first saw the inside of the Palace shortly after her accession in 1837, she wrote in a letter to her half-sister, Feodora, Princess of Hohenlohe-Langenburg, 'there are no less than five fine large rooms, <u>besides</u> the Gallery and dining room, and they are so high, the doors so large, and they lie so well near one another, that it makes an ensemble rarely seen in this country'.

following rooms which allowed increasing degrees of access to the royal presence. Although Nash laid out the state rooms here on this basic pattern, such formalities were already a thing of the past. In any case, had George IV survived to use his new Palace, no great company of guards could have been accommodated in this room, which is one of the most exquisitely wrought of all Nash's interiors. With its ceiling consisting of twenty-eight fitted, curved and deeply cut glass lights set into a matrix of gilded plaster ornaments, it resembles the inside of a giant jewel casket. The plaster reliefs of *War* and *Peace* were modelled by John Thomas. The two marble statues of Queen Victoria and Prince Albert were installed here in 1849.

Tapestries

Two 18th-century Gobelins tapestries from the series *Les Portières des Dieux: Venus*, symbolising Spring (left); *Bacchus*, symbolising Autumn and four narrow panels intended to be hung between windows (*entrefenêtres*)

Sculpture

John Gibson (1790–1866), *Queen Victoria*, 1847; originally partly coloured

Emil Wolff (1802–79), *Prince Albert*, 1846; a replica of the original now at Osborne House, Isle of Wight. The Prince is dressed in ancient Greek costume

Mary Thornycroft (1814–95), *Princesses Victoria and Maud of Wales*, 1877; two of the daughters of King Edward VII

Benjamin Edward Spence (1822–66), *Lady of the Lake*, 1861; Queen Victoria's last birthday present to Prince Albert

Benjamin Edward Spence (1822–66), *Highland Mary*, 1853; a birthday present from Prince Albert to Queen Victoria

Mary Thornycroft (1814–95), *Princess Louise of Wales*, 1877

Furniture

Part of a set of chairs supplied by Morel & Seddon for Windsor Castle, 1826–8

Chandelier, probably supplied by Parker & Perry for Carlton House, c.1811

Sèvres soft-paste porcelain pot-pourri vase, 1758. One of the rarest and most distinctive pieces of Sèvres in the Royal Collection, it originally belonged to Madame de Pompadour, Louis XV's mistress.

The Green Drawing Room

Although Nash used classical proportions for the state rooms of the Palace, he did not always have recourse to the five classical orders. In the Green Drawing Room he divided the walls with entirely abstract pilasters of lattice plasterwork, gilded and filled with thousands of separately cast and applied florets. Nash's pilasters support an equally abstracted frieze of garlands and swags, beneath a robustly geometric ceiling. To the critic Allan Cunningham, writing in *Fraser's Magazine* in 1830, the ceilings of the new Palace (which were not all completed by then), were 'in a style new in this country, partaking very much

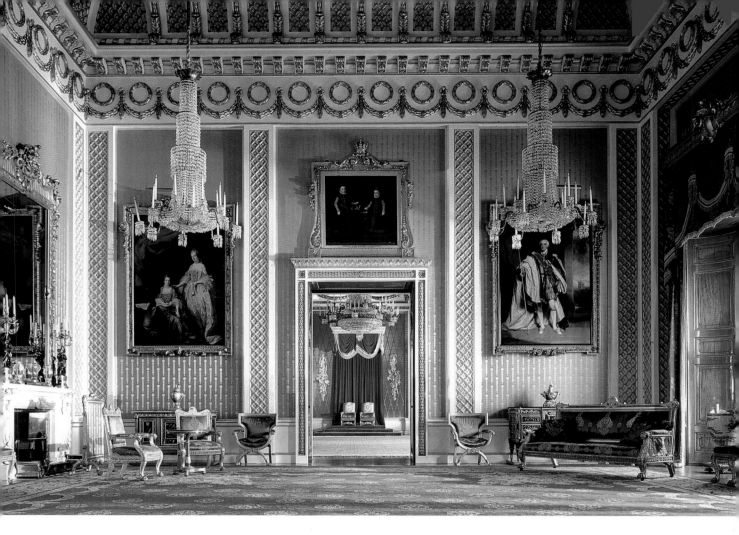

of the boldest style in the Italian taste of the fifteenth century. . . .
It is indeed not easy to conceive anything more splendid.' All of the
applied plasterwork was supplied by the London firm of George
Jackson & Sons, while William Croggon inlaid the borders around
the edge of the floor with repeating paterae and interlace in holly
and satinwood.

The only features of the room which post-date Nash's original
conception are the tall carved and gilt overmantel mirrors, which
probably date from the 1830s.

The room has always been hung with green silk. Originally this was
of the quality known as 'tabinet', woven in Ireland in 1834 by the
special instruction of Queen Adelaide, wife of William IV. This
was replaced in 1864, together with the green and gold silk curtains
and valances. Further replacements have followed roughly every
thirty years since, with some variation in the pattern. One of the
decorative innovations of the Prince Regent's Carlton House
interiors has been perpetuated here, with groups of green-ground
Sèvres porcelain vases deployed to match the wall coverings, while
blue-ground vases may be found in the Blue Drawing Room.

Cabinet with pietra dura *panels by Adam Weisweiler,
c.1780–85. It is enriched with 17th-century panels of
pietra dura; some, such as the two with single flowers,
may have been made in Florence. Those in relief may have
come from the Gobelins manufactory. It was probably
bought by George IV for Carlton House in 1791.*

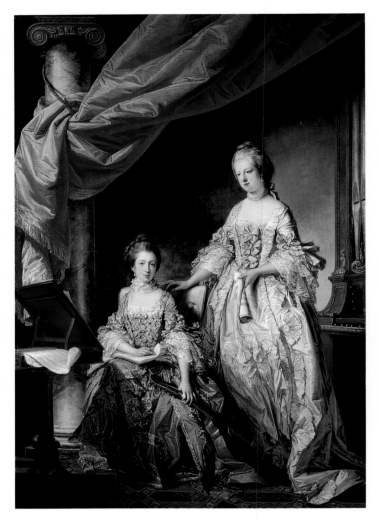

Princesses Louisa and Caroline Matilda
(sisters of George III), Francis Cotes, 1767

Note: To avoid confusion, George IV is referred to in the following pages by his title as King (1820–30). The eldest son of George III and Queen Charlotte, he was created Prince of Wales a week after his birth in 1762, and Prince Regent in 1811.

Pictures

(clockwise from the left of the entrance door)

Nathaniel Dance (1734–1811), *Edward Augustus, Duke of York* (brother of George III), 1764

John Michael Wright (1623–1700), *James, Duke of Cambridge* (1663–7, son of James II and his first wife Anne Hyde), 1666–7

Francis Cotes (1726–70), *Princesses Louisa and Caroline Matilda* (sisters of George III), 1767

Attributed to Sofonisba Anguissola (1527–1625), *Princesses Isabella Clara Eugenia and Catharina* (daughters of Philip II of Spain), c.1569–70

Sir Martin Archer Shee (1769–1850), *Richard, Marquess Wellesley* (1760–1842), c.1832

Studio of Allan Ramsay (1713–84), *Augusta, Princess of Wales* (1719–72)

Furniture

Grand piano by Isaac Mott in a rosewood case inlaid with brass, 1817; purchased by George IV in 1820 for £238 5s, it was originally placed in the Music Room Gallery at the Royal Pavilion, Brighton

Four semi-circular spirally fluted giltwood pedestals, c.1790; probably made in England to a French design, for the Throne Room at Carlton House. The pedestals support French Empire candelabra in gilt and patinated bronze

Part of two suites of carved and gilt mahogany and beech seat furniture made for Windsor Castle by Morel & Seddon, 1826–8

Side table by Adam Weisweiler, veneered with ebony, c.1785; the panels of inlaid and polished *pietra dura* (hardstone) probably date from the late 17th century. It was bought in Paris for George IV in 1816

Regency centre table veneered in rosewood inlaid with brass

Four early 19th-century cut-glass chandeliers

Cabinet by Adam Weisweiler, veneered in ebony with Boulle marquetry, *pietra dura* panels and gilt-bronze mounts, c.1780–85. Purchased by George IV when Prince of Wales

Pair of four-light gilt and patinated bronze candelabra in the form of three female figures standing back to back, by Benjamin Lewis Vulliamy, 1811

French Empire clock with a bronze figure of Apollo, probably designed by Martin-Eloi Lignereux with mounts supplied by Pierre-Philippe Thomire, 1803; bought by George IV in 1810

Pair of French Empire gilt and patinated bronze candelabra

One of a pair of cabinets veneered with Boulle marquetry in tortoiseshell, pewter and ebony, possibly German, late 17th century; the ebony and pewter stand was made by John Bradburn in 1766

Porcelain

Sèvres soft-paste porcelain pot-pourri vase in the form of a ship (*vaisseau à mât*), 1758; it was purchased from the factory at the end of the following year by Louis XV's mistress, Madame de Pompadour, and subsequently acquired by George IV in Paris in 1817 for 2,500 francs

Sèvres porcelain green-ground vases, second half of the 18th century

CARLTON HOUSE

Carlton House stood at the southern side of what is now Waterloo Place, set back from Pall Mall, where now there are steps and the column commemorating Frederick, Duke of York. Formerly the home of Frederick, Prince of Wales, and then of his widow Augusta, Carlton House was allocated to their grandson George, Prince of Wales (1762–1830), on his coming of age in 1783. The Prince commissioned the architect Henry Holland to enlarge and embellish the northern side of the house, adding a grand entrance portico in 1794. This work was followed by a further twenty-five years of almost continuous remodelling, redecoration and rearrangements, in which the Prince was assisted by French decorators including Dominique Daguerre. During the same period, the Prince amassed an outstanding collection of Dutch and Italian paintings, French furniture and porcelain, arms and armour and bronzes, and entertained on a most lavish scale at fêtes in the house and garden on occasions such as the King's Birthday and visits by foreign royalty. According to a French guide to London published in 1823, Carlton House was simply 'the finest palace in the world'. Four years later, persistent structural problems and the need to relocate the collections to Buckingham Palace led to its complete demolition.

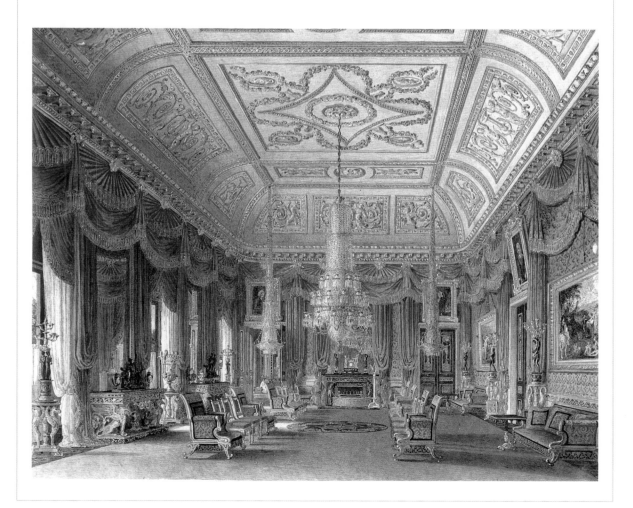

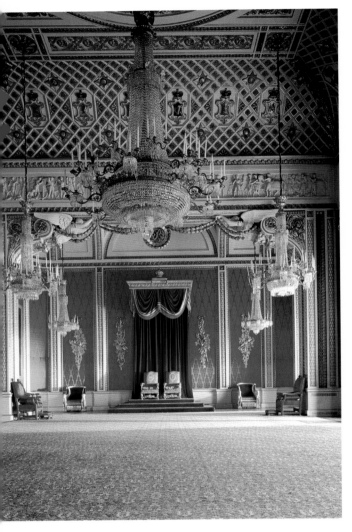

The Throne Room

Of all Nash's interiors at Buckingham Palace, this is one of the most dramatic and convincing. Everything seems contrived to focus the eye on the throne dais and canopy, in effect a stage for the pageantry of monarchy. The canopy and thrones are separated from the body of the room by a proscenium arch, from which two life-size winged *genii*, modelled by Francis Bernasconi and cast in plaster, hold the garlanded initials of George IV.

Like the Green Drawing Room, the Throne Room is classically proportioned whilst avoiding any use of the classical orders. Here, while the walls are simply divided by narrow strips of plaster oak leaves, the real drama takes place in the ceiling, with its dazzling radiating centre. The whole elaborate scheme was the work of several firms and craftsmen. The innumerable separate plaster ornaments – rosettes, leaves and garlands – were supplied by George Jackson & Sons. In the cove, placed against the diagonal lattice work, are shields bearing the arms of the kingdoms of England, Scotland, Ireland and Hanover, the quarterings of the royal arms; and placed above and below these are alternating badges of the two senior orders of knighthood, the Garter and the Bath. This heraldic work in cast, painted and gilded plaster was supplied by the firm of Bullock & Carter. But the most original feature of the room is undoubtedly the lengthy plaster frieze, designed by Thomas Stothard and modelled in clay by Edward Hodges Baily, before being cast in plaster in several sections and fixed in position. It represents episodes from the Wars of the Roses, divided into four scenes.

The dominant theme of the Throne Room, expressed through the friezes and the national heraldic emblems, is the role of monarchy in unifying the kingdoms and enabling the fruits of peace to flourish. The medieval character of the friezes, and the heraldic panoply above them, recall the richly historical pageantry of George IV's coronation in 1821, when the King and his court processed to Westminster Abbey in extravagant medieval costumes. Here in the Throne Room at Buckingham Palace the most theatrical monarch in British history was ably served by the genius of theatre architecture, John Nash, but since the Palace remained unfinished at the time of his death, George IV never took the stage. The plaster bust of his younger brother, who succeeded him as William IV in 1830, therefore occupies the place of honour in the doorcase

ABOVE: *Detail of the 'proscenium' arch in the Throne Room.*

THE THRONE ROOM FRIEZE

Over the entrance door Bellona, the goddess of discord, urges on the opposing sides. Beneath her feet, two pairs of figures represent, in Stothard's words, 'a son recognising, as an enemy, his dying father; and a dying son lamented by the father. This I have taken from Shakespeare; too strong and forcible an image of the time to be omitted.'

Above the proscenium arch is the Battle of Tewkesbury (1471). The young Prince Edward, son of Henry VI, surrounded by officers, is struck in the face by Edward IV as a signal for his assassination by the dukes of Clarence and Gloucester, while men-at-arms lead Queen Margaret away to the Tower of London.

Opposite the windows is the Battle of Bosworth Field (1485). Sir William Stanley places on the head of Henry VII the crown which the defeated Richard III had worn on the field of battle. At either end, Stothard introduced two of Richard III's blackest deeds, the murder of the princes in the Tower (right) and the false accusation of Hastings (left).

Over the windows is the marriage of Henry VII and Elizabeth of York (daughter of Edward IV), which brought about the unification of the houses of York and Lancaster, represented by the white and red roses. To contrast with the opposite

frieze, Stothard placed groups of dancers and 'a family in peace and security, a father instructing his sons, and a mother her daughters, in various occupations'.

For his imagery, Stothard drew inspiration from Shakespeare's versions of these historical events, based on his own careful study of medieval costume, armour and weaponry. He was one of several antiquaries who sought to introduce historical accuracy into stage design and costumes. In 1829 his contemporary J.R. Planché published a set of costume designs for Shakespeare's *Richard III*, based on the study of manuscript illumination, effigies and inventories; while Stothard's son Charles Alfred Stothard's *Monumental Effigies of Great Britain* appeared in 1817.

opposite the throne, protected by two guardian angels. The doorcase was made in scagliola by William Croggon from models by William Pitts. Queen Victoria was the first monarch to make use of the Throne Room; with its chandeliers lit by over two hundred candles, it was the central setting for the spectacular costume balls of the 1840s. Later, in the reign of King George V, the Throne Room was used for investitures and the reception of deputations presenting addresses to the King. The modern crimson silk hangings represent a return to the original scheme for the room; for much of the last century the walls were painted a light stone colour.

Many of the furnishings and fittings in this room were formerly at Carlton House, including the carved and gilt trophies of *c.*1795 representing the Four Seasons to either side of the canopy, which are said to have come from Carlton House's own Throne Room.

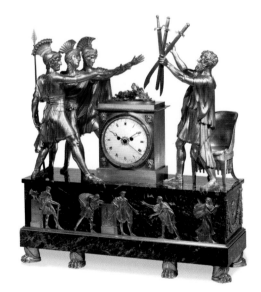

The 'Oath of the Horatii' clock by Claude Galle, c.1800. Based on the famous painting by Jacques-Louis David of 1784, it was purchased by George IV in 1809.

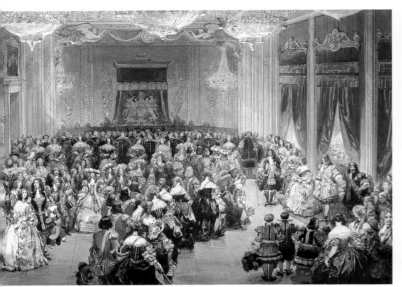

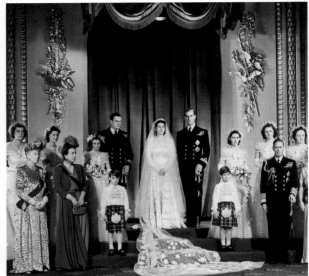

Picture

Angelica Kauffmann (1741–1807), *Augusta, Duchess of Brunswick, with her son Charles*, 1767. Augusta was the sister of George III and mother of Caroline, consort of George IV

Furniture

Throne chairs made in late 17th-century style by White Allom & Co. for the use of HM The Queen and The Duke of Edinburgh at the coronation ceremony of 1953

Throne chairs made in Jacobean style by White Allom for the use of King George VI and Queen Elizabeth at the coronation ceremony of 1937

Throne chair made for Queen Victoria by Thomas Dowbiggin, 1837

Pair of council chairs in carved and giltwood with silk velvet upholstery, made for the Council Room at Carlton House by Tatham & Co. in 1813; the design of the chairs was based on drawings of ancient Roman thrones by C.H. Tatham

Regency cut-glass and gilt-bronze chandeliers, probably from Carlton House, *c.*1810

Clock with gilt-bronze figures and frieze representing the Oath of the Horatii (after Jacques-Louis David), by Claude Galle, *c.*1800

Pair of gilt and patinated bronze candelabra in the form of cornucopia, attributed to Claude Galle, early 19th century; purchased by George IV in 1814

Pair of Regency giltwood and crimson velvet benches from the Ante-Throne Room at Carlton House

Sculpture

(in the niche by the thrones) Carlo Marochetti (1805–69), *Prince Arthur, c.*1855

Carlo Marochetti, *The Duchess of Teck* (mother of Queen Mary; 1805–69)

John Gibson (1790–1866), *Alexandra, Princess of Wales*, 1863

LEFT: *The Throne Room in use for the Stuart Ball on 13 June 1851. Watercolour by Eugène Lami.*

BELOW: *Council chair made for the Council Room at Carlton House by Tatham & Co., 1813.*

ABOVE: *The Royal Family photographed in the Throne Room on the occasion of the marriage of Princess Elizabeth with Lieut. Commander Philip Mountbatten, Duke of Edinburgh, 20 November 1947.*

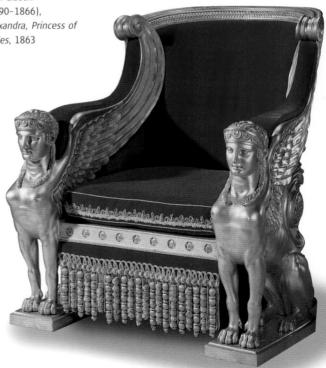

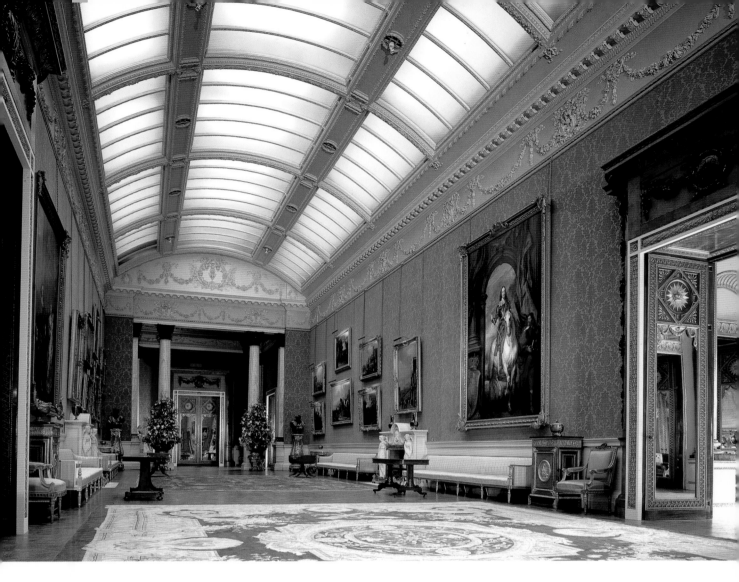

The Picture Gallery

By placing this great gallery at the very centre of the Palace, Nash created a worthy and prominent setting for George IV's picture collection, much of which had been kept in semi-permanent storage since acquisition, simply for lack of wall-space at Carlton House.

Despite the outstanding quality of the pictures – by Holbein, Rembrandt, Rubens, Canaletto and others – this has never been a gallery in which the works of art are intended to be regarded with the sort of hushed reverence that reigns in museums. Nash planned it on the first floor so that it could act as one of the principal reception rooms of the Palace, a role it still performs today. Receptions are held here for several hundred guests at a time, each recognising achievement in a particular walk of life or sector in the community – such as sport, the arts, the voluntary services, industry, and innovation. The gallery is also occasionally used for banquets in support of charities or organisations with royal patrons,

The four marble chimneypieces were carved by Italian sculptors under the supervision of Joseph Browne and working from designs supplied by Nash, perhaps through the intermediary of Flaxman. Each consists of a pair of female genii *representing Painting, who stand with palettes and brushes in their hands, supporting a garlanded medallion of one of the great painters: Titian and Leonardo da Vinci at the northern end of the gallery, and Dürer and Van Dyck at the southern end. These were originally joined by others including Michaelangelo and Raphael.*

and throughout the year it is here that the recipients of honours assemble before being led into the Ballroom for investitures.

A second important reason for the location of the gallery was to take advantage of natural light from above ('top-lighting'), which by the early nineteenth century was considered essential for the viewing of pictures. Drawing on his previous experiments in gallery design, beginning at Attingham Park in Shropshire twenty years earlier, Nash divided the ceiling into three longitudinal zones, installing seventeen glass saucer-domes along the sides and leaving the centre unglazed. The domes, which were engraved like that over the Grand Staircase, were held in ornamental plaster vaults which gave a pleasing rhythm to such a long room. The gallery was declared ready for hanging with pictures by Christmas 1835, and the first arrangement was made by William Seguier (d.1843), who had served George IV as Surveyor of The King's Pictures and continued in that role into the early years of the reign of Queen Victoria.

By the end of the nineteenth century Blore's central glazing had begun to let in rainwater, but it was not until 1914–15 that it was replaced by the present design, by the chief architect of the Board of Works, Frank Baines (1877–1933). This entailed an entirely new segmental glazed ceiling set 60 cm (2 feet) lower than its predecessor. At the same time the cornice and plaster frieze were

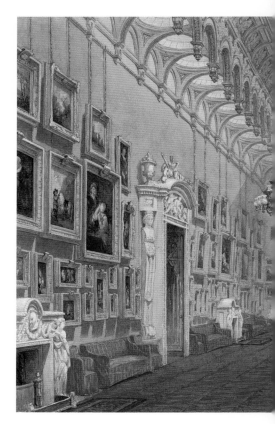

The Picture Gallery in 1843.
Watercolour by Douglas Morison.

A ROYAL COLLECTOR

The 47-metre (154-foot) gallery now contains works from many periods, almost all of them acquired by one of the four most important royal collectors of pictures: George IV; his father George III and grandfather Frederick, Prince of Wales; and the greatest of them all, Charles I, who appears himself in two colossal paintings by the Flemish painter Anthony Van Dyck (1599–1641) in the centre of the gallery. The earlier portrait, the family group known in Charles I's time as *The Greate Peece*, was painted in 1632, the year in which Van Dyck was appointed court painter. The King, his French wife Henrietta Maria and their eldest children, Charles, Prince of Wales, and Mary, Princess Royal, are depicted at Whitehall Palace, with a distant view of Westminster and the Thames. In the second picture the King rides through a triumphal arch in armour on a powerful white horse, an image intended to display confidence, fearlessness and control. Charles I's collection was auctioned by the Parliamentary authorities after his execution in 1649, and although the two Van Dyck portraits and many others were subsequently returned to the Royal Collection, the majority of his pictures remain dispersed in other collections throughout Europe and North America.

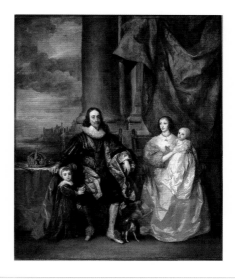

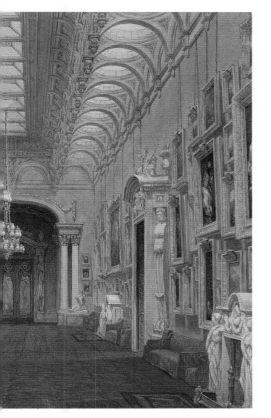

added to reduce the area of the walls, and the pictures, though still very numerous, were all hung at a lower level than previously. The doorcases were modelled by William Pitts and formed in stucco and scagliola by William Croggon. They resembled his one surviving doorcase in the Throne Room, but with the addition of flanking terms with the head of Apollo, the god of artistic inspiration. During the 1915 remodelling, the door surrounds were encased by the present panelling embellished with seventeenth-century style carvings by H.H. Martyn of Cheltenham. The remodelling entailed the flattening of the curved arches and reordering of the columns at each end of the gallery, and the replacement of the parquet floor.

Several colour schemes have been employed in the Picture Gallery. Early views such as the watercolour of 1843 by Douglas Morison (left) show a warm biscuit colour which was also used at that time on the Grand Staircase. Under Prince Albert's direction, a dramatic departure was made in 1851 when the walls were painted in lilac, and the ceiling picked out in terracotta and blue. King Edward VII hung the gallery with bright yellow silk, which King George V ordered to be replaced in green following the remodelling of 1915. When these hangings had become unacceptably faded by 1946, the decision was taken simply to rehang them back to front, an instance of post-war economy. The present decorative scheme dates from 1964.

Guercino, The Libyan Sibyl, *1651*

Jan Steen, Interior of a tavern, *c.1665*

Rembrandt van Rijn, The Shipbuilder and his wife, *1633*

Pictures (listed from the Throne Room end of the gallery)

Note: The historic frames of some of the pictures retain old labels and numbers that may no longer be accurate.

End wall

Guercino (1591-1666), *The Libyan Sibyl*, 1651

Antonio Canaletto (1697-1768), *A caprice view with a painted arch*, c.1735-40

Guido Reni (1575-1642), *The Death of Cleopatra*, c.1628

Antonio Canaletto (1697-1768), *A caprice view with ruins*, c.1728

Left-hand wall

David Teniers the Younger (1610-90), *The Stolen Kiss*, c.1640

Jan Steen (1626-79), *Interior of a tavern with cardplayers and a violin player*, c.1665

Sir Anthony Van Dyck (1599-1641), *Virgin and Child*, c.1630-32

Aelbert Cuyp (1620-91), *The Passage Boat*, c.1650

Nicolaes Berchem (d.1685), *A mountainous landscape with herdsmen driving cattle down a road*, c.1673

Sir Anthony Van Dyck (1599-1641), *Zeger van Hontsum*, c.1630

Francesco Zuccarelli (1702-88), *Landscape with two young children offering fruit to a woman*, c.1743

David Teniers the Younger (1610-90), *Fishermen on the seashore*, c.1660

Domenico Feti (1589-1624), *Portrait of Vincenzo Avogadro*, c.1620

Rembrandt van Rijn (1606-69), *The Shipbuilder and his wife*, 1633

Aelbert Cuyp (1620-91), *Cows in a pasture beside a river before the ruins of the Abbey of Rijnsberg*, c.1640-50

Rembrandt van Rijn (1606-69), *Portrait of Agatha Bas*, 1640

Sir Anthony Van Dyck (1599-1641), *Charles I and Henrietta Maria with their two eldest children ('The Greate Peece')*, 1632

Antonio Canaletto (1697-1768), *Venice: The Piazzetta towards the Torre dell'Orologio*, c.1728

Luca Carlevaris (1665-1731), *A caprice landscape with a fountain and an artist sketching*, c.1710

Gaspard Dughet (1615-75), *Seascape with Jonah and the whale*, c.1653

Melchior de Hondecoeter (1636-95), *Birds and a spaniel*, c.1665

Sir Peter Paul Rubens (1577-1640), *Landscape with St George and the dragon*, c.1630

Luca Carlevaris (1665-1731), *A caprice view of a seaport*, c.1710

Claude Lorrain (1600-52), *A view of the Roman Campagna from Tivoli*, 1645-6

ABOVE: *Claude Lorrain,* A view of the Roman Campagna from Tivoli, *1645–6*

BELOW: *Antonio Canaletto,* Venice: The Piazzetta towards the Torre dell'Orologio, *c.1728*

RIGHT: *Sir Peter Paul Rubens,* The Assumption of the Virgin, *c.1611*

Right-hand wall

Artemisia Gentileschi (1597–1651), *Self-portrait as* La Pittura *(Painting), c.1635–7*

Georges de la Tour (1595–1652), *St Jerome, c.1621–3*

Philips Wouwermans (1619–68), *The Hayfield, c.1660*

Sir Peter Paul Rubens (1577–1640), *The Assumption of the Virgin, c.1611*

Sir Anthony Van Dyck (1599–1641), *The Mystic Marriage of St Catherine, c.1630*

Sir Peter Paul Rubens (1577–1640), *Milkmaids with cattle in a landscape ('The Farm at Laeken'),* panel. *c.1617–18*

Philips Wouwermans (1619–68), *A horse fair in front of a town, c.1660*

Attributed to Isaac van Ostade (*c.1629–49*), *Girl crossing a brook, c.1645*

Francesco Zuccarelli (1702–88), *Landscape with two seated women embracing, c.1743*

Cristofano Allori (1577–1621), *Judith with the head of Holofernes, 1613*

Willem van de Velde the Younger (1633–1707), *A Calm: A States Yacht, a barge, and many other vessels under sail, 1659*

Sir Anthony Van Dyck (1599–1641), *Christ healing the paralytic, c.1619*

Lorenzo Lotto (1480–1556), *Portrait of Andrea Odoni, 1527*

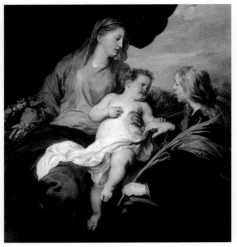

Sir Peter Paul Rubens, Landscape with St George and the dragon, *c.1630*

Sir Anthony Van Dyck, The Mystic Marriage of St Catherine, *c.1630*

Carlo Dolci (1616–86), *Salome with the head of St John the Baptist,* 1670

Willem van de Velde the Younger (1633–1707), *The* Gouden Leeuw *at sea in heavy weather,* c.1671

Sir Anthony Van Dyck (1599–1641), *Charles I with M. de St Antoine,* 1633

Antonio Canaletto (1697–1768), *Venice: Piazza S. Marco from a corner of the Basilica,* 1728

Luca Carlevaris (1665–1731), *A caprice view with a shipyard,* c.1710

Gaspard Dughet (1615–75), *Landscape with a waterfall,* 1653–4

Jan Steen (1626–79), *A village revel,* c.1673

Jan Both (1618–52), *Landscape with St Philip baptising the eunuch,* c.1640–49

Luca Carlevaris (1665–1731), *A caprice view of a harbour,* c.1710

Lorenzo Lotto, Portrait of Andrea Odoni, *1527*

Gaspard Dughet (1615–75), *Landscape with figures by a pool,* c.1665

Furniture

Pair of cabinets by Pierre Garnier, veneered with ebony and inlaid with panels of pewter, tortoiseshell and brass, c.1770; bought for George IV in Paris in 1819

Four carved and giltwood armchairs by Georges Jacob, c.1786; imported to England by Dominique Daguerre in the 1780s, and

originally placed in George IV's bedroom at Carlton House

Set of four French marble-topped console tables veneered in tulipwood, attributed to Adam Weisweiler, c.1785; the gilt-bronze scrollwork in the friezes was added by Benjamin Lewis Vulliamy in 1811

Two pedestals by Gilles Joubert, veneered with trellis marquetry in kingwood and tulipwood, 1762; made to support clocks giving solar and lunar time (as indicated by the gilt-

bronze mounts emblematic of Apollo and Diana), they originally stood on either side of the alcove in Louis XV's bedroom at Versailles. They now support 18th-century French bronze busts of the emperors Augustus and Vespasian. Acquired by George IV in 1818

Two pairs of Boulle cabinets in brass and pewter with gilt-bronze figurative plaques and friezes, acquired by George IV in 1828

Porcelain and lacquer

Japanese 17th-century lacquer bowls with French gilt-bronze mounts in the Louis XV and Louis XVI styles, 18th century

Two pairs of hard-paste Sèvres porcelain vases, painted in platinum and gold on a black ground with chinoiserie scenes to imitate Japanese lacquer, mounted in gilt-bronze, c.1790–92; and another pair, with an undecorated black ground and siren mounts, c.1786

Pair of *lac burgauté* vases (lacquer and mother-of-pearl applied to porcelain), with gilt-bronze mounts by B.L. Vulliamy, early 19th century

Pair of large 18th-century Chinese celadon vases mounted as ewers with early 19th-century French gilt-bronze mounts

The Picture Gallery Lobby

Embroidery

Large mid-17th-century Italian needlework panel of the *Annunciation*

Furniture

Set of partly gilt lyre-backed mahogany chairs, probably made for Carlton House by François Hervé, *c.*1790

Porcelain

Pair of large octagonal late 18th-century Chinese porcelain vases

RIGHT: *Sir Francis Chantrey,* Mrs Jordan and two of her children, *1834. The subject, Dorothy (Dora) Jordan (1761–1816), was the greatest comic actress of her generation and the mistress of William, Duke of Clarence, by whom she had five sons and five daughters. They took the name Fitzclarence, and the eldest son, George Augustus Frederick, was created Earl of Munster in 1831. The Duke of Clarence dismissed Dora in 1812 and she died in penury in France four years later. One of the Duke's first acts on succeeding as William IV in 1830 was to summon Chantrey to create a marble monument to Mrs Jordan in which the quality of 'maternal affection' should be emphasised. It was intended to stand in Westminster Abbey, but this was not allowed and the statue passed down in Dora's family until 1975, when it was bequeathed to The Queen by the 5th Earl of Munster. It was placed here in 1980.*

The Silk Tapestry Room

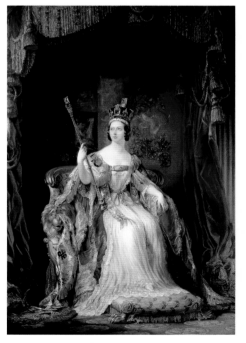

The Silk Tapestry Room serves to connect Nash's state apartments with the rooms added for Queen Victoria in 1856. The single seventeenth-century Italian embroidery panel in the Picture Gallery Lobby formerly hung, with three others, in this room, and although these were moved elsewhere in 1965 when the room was redecorated, the old name has been retained.

Pictures

Sir George Hayter (1792–1871), *The Christening of the Prince of Wales*, 1842–5; the ceremony took place in St George's Chapel, Windsor, on 25 January 1842

Sir George Hayter (1792–1871), *Queen Victoria*, 1840; a version of the State Portrait of the young Queen, enthroned and dressed in coronation robes

Benjamin Robert Haydon (1786–1846), *The Mock Election*, 1827; the painting depicts a scene in King's Bench Prison, where the unfortunate Haydon was himself detained for debt

Sir George Hayter, Queen Victoria, *1840*

Furniture

Marble-topped mahogany cabinet by Adam Weisweiler with gilt-bronze mounts, late 18th century

Table by Morel & Seddon supporting an Italian *pietra dura* slab, *c.*1828

Giltwood side table with specimen marble top, attributed to Mayhew & Ince, *c.*1775; purchased by Queen Mary in 1931

French marble and gilt-bronze clock by François-Louis Godon, carved with figures of Venus and Cupid, 1792

Monumental pedestal clock, veneered with tulipwood and fitted with elaborately chased gilt and patinated bronze mounts; probably made in the 1730s, possibly by Jean-Pierre Latz, and bought by George IV for Carlton House in 1816. The English movement is by Vulliamy

Sculpture

Carlo Marochetti (1805–67), *Edward, Prince of Wales* (the 'Black Prince'), *c.*1860

Carlo Marochetti (1805–67), *Richard I*, *c.*1860. A reduction of the colossal bronze statue by Marochetti erected in Old Palace Yard at the Palace of Westminster in 1860

A full-size companion statue of the Black Prince was proposed but never executed. Both statuettes were bought by Queen Victoria in 1868

The East Gallery

On leaving the Silk Tapestry Room, the visitor enters the principal Victorian addition to the Palace, which was built on and around the site of the libraries that George III's architect William Chambers added to Buckingham House at the end of the eighteenth century. Once George III's books had been presented to the nation by his son George IV these fine rooms became redundant, and under Nash's reconstruction only one of them, the great Octagon Library, was spared.

Sir James Pennethorne's design for the East or 'Promenade' Gallery drew on the architectural vocabulary developed for the Palace by his former employer John Nash. As well as replicating Nash's glazed mahogany doors and the use of top-lighting, Pennethorne made use of a fifth marble chimneypiece of the same design as those in the Picture Gallery, this time with a medallion of Rembrandt.

The East Gallery is part of the main route by which guests reach the Ballroom from the Grand Entrance.

John Hoppner, Mrs Jordan as the Comic Muse, *1786*

Sir George Hayter, The Coronation of Queen Victoria, *1838*

ABOVE: *These panels painted in imitation of reliefs on a gold ground by Nicola Consoni are the only visible remains of the decorations devised by Ludwig Gruner.*

LEFT: *Benjamin West,* The Departure of Regulus, *1769*

Pictures

End wall

John Hoppner (1758–1810), *Mrs Jordan as the Comic Muse*, 1786

Right-hand wall

Benjamin West (1738–1820), *Queen Charlotte*, 1782

Benjamin West (1738–1820), *Prince Adolphus with Princesses Mary and Sophia*, 1778

Benjamin West (1738–1820), *George III*, 1779

John Hoppner (1758–1810), *Francis, 5th Duke of Bedford*, c.1797

Sir George Hayter (1792–1871), *The Coronation of Queen Victoria*, 1838

John Hoppner (1758–1810), *Francis, 5th Earl of Moira and 1st Marquess of Hastings*, c.1793

Sir Thomas Lawrence (1769–1830), *Caroline, Princess of Wales, and Princess Charlotte*, 1802; the consort and only child of George IV

Left-hand wall

Sir Peter Paul Rubens and studio, *The Family of Balthasar Gerbier*, c.1629–30

John Russell (1745–1806), *George, Prince of Wales* (later George IV), 1791. The Prince is wearing the uniform of the Royal Kentish Bowmen

Benjamin West (1738–1820), *The Departure of Regulus*, 1769

Benjamin West (1738–1820), *The apotheosis of Prince Octavius*, 1783

Furniture

Large clock signed by the Parisian bronze manufacturer De La Croix, gilt and patinated bronze, c.1775; the pedestal incorporates four gilt-bronze plaques of 16th-century French design. The clock dial and movement are by B.L. Vulliamy, c.1851

Two pairs of gilt and patinated bronze candelabra by Pierre-Philippe Thomire (1751–1843), c.1810; purchased by George IV in 1813. They stand on French early 19th-century ebony and brass pedestals

Porcelain

Pair of Sèvres porcelain vases with gilt-bronze mounts, c.1791–2

The Ball Supper Room

Once it had been decided to build a new Ballroom for Queen Victoria, the provision of a Supper Room on a scale sufficient to provide refreshment for several hundred guests at a time was an unavoidable necessity. The design of both rooms was undertaken by Sir James Pennethorne, and it was the Supper Room that finally put paid to the shell of George III's Octagon Library, which formerly occupied this site. The plaster groups over the doorcases (two groups representing Bacchus and Flora repeated twice) were modelled by William Theed the Younger (1804–91) to designs by John Gibson. One of the marble chimneypieces includes busts of George IV and William IV and was designed by Nash for use elsewhere, while the other is a copy contemporary with the room, including busts of Queen Victoria and Prince Albert. Pennethorne's design envisaged a continuous serving table 41 metres (135 feet) in length arranged in a horseshoe shape around the room. Another lengthy table was intended to be set up in the East Gallery for the serving of tea and coffee at state balls.

In modern times the Ball Supper Room itself is used each year as a ballroom during The Queen's Diplomatic Reception and Christmas Dance. When the Palace is open during August and September, a special display is mounted here as part of the tour of the state rooms.

The Ballroom

When first completed in 1855, this enormous room, measuring 14 metres high, 34 long and 18 wide (46 × 112 × 59 feet) was known as the Ball and Concert Room. It was first used for a ball on 8 May 1856. The musicians' gallery is today occupied during investitures, banquets and receptions by one of the bands of the Household Division.

At the other end of the room, plaster statues by William Theed stand on top of a triumphal arch, flanked by sphinxes and enclosing the throne canopy. The pair of winged figures at the summit of the arch symbolises History and Fame. They support a medallion with the profiles of Queen Victoria and Prince Albert. The throne canopy beneath them was created in 1916 using heavy gold-embroidered velvet hangings salvaged from the imperial canopy or *shamiana* made for King George V and Queen Mary's appearance at

Furniture

French mantel clock by Louis Moinet (1758–1853), surmounted by a gilt-bronze figure of Apollo with his lyre

Two pairs of French gilt and patinated bronze candelabra with female figures, *c.*1795

Thermometer by Mortimer & Hunt surmounted by a gilt-bronze figure of Diana; acquired with the French clock from the firm of Thomire by George IV in 1828

THE ORGAN

Originally supplied in 1817 for the Music Room at Brighton Pavilion by Henry Cephas Lincoln, the organ was moved here after Queen Victoria sold the Pavilion to the Corporation of Brighton in 1848 and had the contents and fittings brought to London for incorporation in the new additions to Buckingham Palace. The organ was rebuilt and extended by Gray & Davison and installed in a new case designed by Pennethorne, flanked by plaster figures symbolising Music and modelled by William Theed. The gilt plaster roundels represent Handel, whose music had been championed at the English court ever since the reign of George III. The latest restoration of the organ was completed in time for The Queen's Golden Jubilee in 2002 and it has subsequently been used for broadcasts and performances.

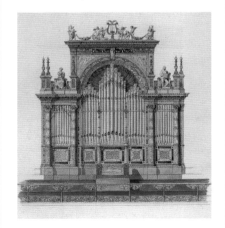

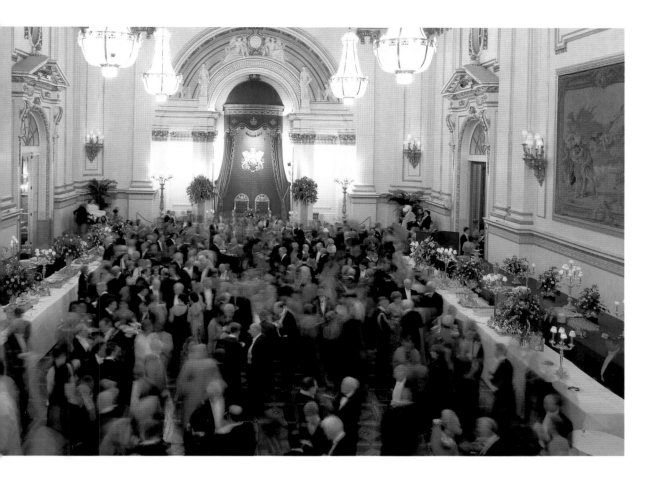

The Ballroom in use for the service of dinner at the Diplomatic Reception, 10 November 2004. Early in November every year The Queen entertains the entire Diplomatic Corps at a reception, attended by 1,300 guests representing 172 countries, either in full civil or military evening dress or in national costume.

the Delhi Durbar of 1911. The present hangings were supplied by the London firm of Heal & Sons in 1967. When the Ballroom was originally completed, gas-lit pendants by Osler of Birmingham were fitted in the ceiling panels, while further gas appliances were placed behind the windows at the upper level. The present chandeliers were supplied in 1907.

The painted decoration of the organ case is all that survives of the very elaborate scheme devised for the room by Prince Albert with his artistic adviser Ludwig Gruner (see page 29). The present white-and-gold decoration was introduced by King Edward VII, who employed the architect Frank Verity and the contractor White Allom to remodel the room with an order of giant fluted Ionic pilasters in 1904–7.

Each year the Ballroom is the setting for twenty investiture ceremonies at which the recipients of honours published in The Queen's New Year and Birthday Honours Lists are invested with their insignia by The Queen, for whom The Prince of Wales

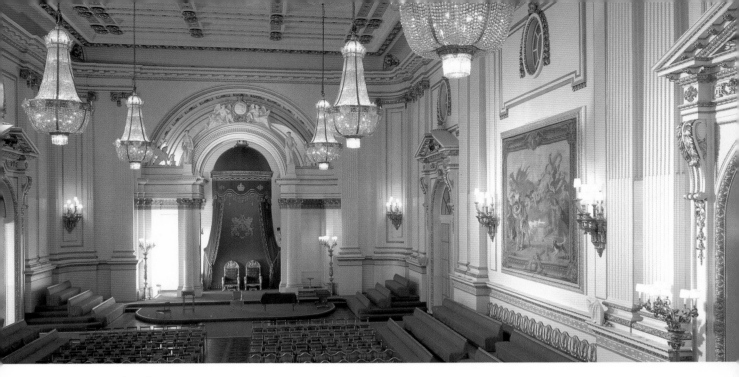

The Ballroom

sometimes deputises. Examples of all the civil and military insignia distributed are on display when the Palace is open during August and September, together with the robes of the senior orders and the sword which The Queen uses to bestow knighthoods. It was her father King George VI's sword as an officer in the Scots Guards.

On the evening of the first day of a state visit, The Queen, accompanied by other members of the Royal Family, entertains the visiting head of state at a state banquet in the Ballroom, at which 160 guests are seated at a long horsehoe-shaped table. These full-dress occasions are part of a tradition of royal hospitality which is as old as the institution of monarchy itself. The tables are ornamented with the finest silver-gilt plate from the Royal Collection, and a magnificent 'buffet' of embossed dishes, cups and sconces is set up on long sideboards to either side of the room.

Tapestries

Two French Gobelins panels woven in 1776 from designs by J.F. de Troy, with episodes from the story of Jason as recounted by Ovid: (right-hand wall) *Medea, having killed her two children, sets fire to Corinth and departs to Athens*; (left-hand wall) *The soldiers born from dragons' teeth take up arms against each other*; acquired by

George IV in 1825 with a further six panels (now at Windsor Castle)

Six gilt-bronze standard torchères from a set of ten supplied for the Ballroom by Ferdinand Barbedienne in 1856, originally fitted for forty-three candles each

Pair of carved and giltwood throne chairs made by Carlhian & Baumetz of Paris under the direction of Joseph Duveen, for the use of King Edward VII and Queen Alexandra at the coronation ceremony of 1902

THE QUEEN AS 'FOUNT OF HONOUR'

The award of honours recognises service to the nation and community by individuals or groups in all walks of society. The majority of awards are made in the New Year and Birthday Honours Lists, published on New Year's Day and in early June (to coincide with The Queen's Official Birthday) each year.

The Order of the Garter (founded 1348), Order of the Thistle (revived 1687), Order of Merit (founded 1903), Royal Victorian Order (founded 1897) and Royal Victorian Chain are in The Queen's personal gift. Other honours, including appointments to the Orders of the Bath (1725), St Michael and St George (1818), and the Order of the British Empire (1917), are made on the advice of ministers.

Within the British honours system, to be knighted or appointed a dame allows a gentleman to bear the title 'Sir' and a lady the title 'Dame'. Most honours and decorations also allow the bearer to place letters after their name, such as OBE.

In the Ballroom there is a display of the insignia of the principal orders.

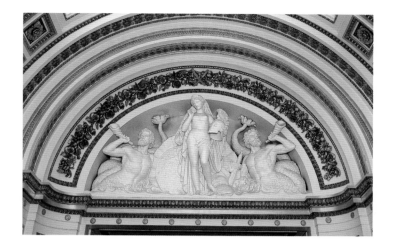

Detail of the plaster sculpture by William Theed in the West Gallery. It depicts Thetis bearing the armour of Achilles.

ABOVE: *The West Gallery during the Blitz. All the state rooms were mothballed and their contents removed to safety. Cases of china were stored at Underground stations, cupboards were turned to face the walls to protect the glass, and the majority of the pictures were removed, with those from the National Gallery, to underground storage in Wales. For six years nothing but essential maintenance could be undertaken.*

The West Gallery

There are two entrances to the Ballroom, and their function and status recall the architecture of a medieval Great Hall: the door from the East Gallery leads to the 'lower' end of the Ballroom and is the public or general entrance, while the door from the Throne end leads through the rooms along the west front to the private apartments. At investiture ceremonies, The Queen and her attendants enter via the West Gallery to stand on the dais, but at state banquets The Queen leads her principal guest and others in a procession from the main body of the state apartments into the Ballroom via the East Gallery.

The West Gallery (originally called the Approach Gallery) was designed by Pennethorne as a link with Nash's state rooms, whose style it follows closely. In the lunettes at either end are plaster groups in high relief modelled by William Theed: *The Birth of Venus* and *Thetis bearing the armour of Achilles.*

Tapestries

Four panels from a series of 28 illustrating the exploits of Don Quixote after designs by C. Coypel, woven at the Gobelins manufactory, second half of the 18th century: *The false princess Micomicon beseeches Don Quixote to restore her to the throne; Don Quixote cured by wisdom of his folly; Sancho Panza despairs at the loss of his donkey; Sancho Panza's memorable judgement.* The series was first woven in 1714, and the *damas cramoisi* ground was introduced after 1760. The four tapestries were presented in 1788 by Louis XVI to the miniaturist Richard Cosway, who gave them shortly afterwards to George IV.

Furniture

French knee-hole desk with Boulle marquetry in tortoiseshell, ebony and brass, late 17th century

Giltwood chairs designed by Robert Jones and made by Tatham, Bailey & Sanders for the Royal Pavilion, Brighton, 1817

Porcelain

Four Chinese porcelain vases on marble bases with gilt-bronze mounts by B.L. Vulliamy, 1808–14

Two Chinese porcelain Imari-pattern square baluster vases and covers, c.1750

The State Dining Room

The great advantage of the series of rooms on the west side of the principal floor is the view of the 16-hectare (40-acre) garden. Late on a summer afternoon the rooms are flooded with sunlight and filled with fresh air, often carrying the scent of new-mown grass and instilling a unique sense of *rus in urbe*, the phrase which was carved on the cornice of the Duke of Buckingham's house on this site.

The initials of both William IV and Queen Victoria appearing in roundels in the cove are indications that this room, at the extreme south-west corner of Nash's original state apartments, was among the last to be completed after the death of George IV in 1830 brought the construction of the Palace to an abrupt but temporary halt.

The design of the ceiling is by Edward Blore. The ornaments, some of which were made in gilded papier mâché by the firm of C.J. Bielefeld, are generally looser and more florid than Nash's. Blore also designed the overdoors, pier glasses and pelmets, and the matching picture frames, supplied by Ponsonby & Co. in 1840, containing a series of paired portraits of the Hanoverian sovereigns and consorts from George I to George IV. Space, and perhaps also discretion, prevented the inclusion of George IV's 'unruly queen', Caroline of Brunswick. Like the series on the Grand Staircase, this arrangement was Queen Victoria's idea.

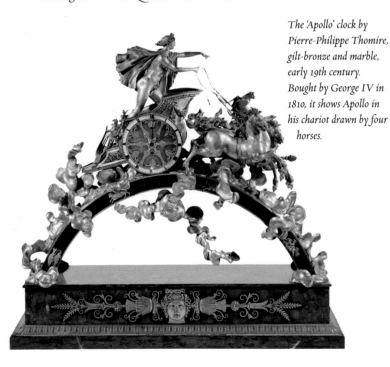

The 'Apollo' clock by Pierre-Philippe Thomire, gilt-bronze and marble, early 19th century. Bought by George IV in 1810, it shows Apollo in his chariot drawn by four horses.

Pictures
(from left to right)

Sir Godfrey Kneller (1646–1723), *Caroline, Princess of Wales* (later Queen, wife of George II), 1716

Jean-Baptist van Loo (1684–1745), *Frederick, Prince of Wales*, 1742

Allan Ramsay (1713–84), *Queen Charlotte* (wife of George III), c.1763

Studio of Sir Thomas Lawrence (1769–1830), *George IV in Garter robes*, c.1820

Studio of Allan Ramsay (1713–84), *George III*, c.1763

Jean-Baptist van Loo (1684–1745), *Augusta, Princess of Wales* (wife of Frederick), 1742

Studio of John Shackleton (*fl.*1742–67), *George II*, 1755–7

Furniture

Pair of gilt-bronze candelabra by Thomire & Cie with malachite bases, purchased by George IV in 1828, standing on Regency giltwood tripods carved with griffins

Set of partly gilt mahogany sideboards with gilt-bronze and mirrored backs, 1838

Clock by Benjamin Vulliamy in marble and gilt-bronze with three figures in biscuit porcelain by William Duesbury, 1788; designed for George IV when Prince of Wales

Gilt-bronze and red marble mantel clock by Pierre-Philippe Thomire (1751–1843) with Apollo driving his chariot through clouds

Set of four gilt-bronze candelabra modelled with camels' legs and crescents on red marble bases by François Rémond; they were completed in 1783 for the 'Turkish' apartment of the Comte d'Artois (later Charles X of France) at Versailles. The maize cob in the centre was assumed at the time to be a Turkish plant. Purchased by George IV in 1820

Four 19th-century English cut-glass and gilt-bronze chandeliers

Silver-gilt
(on the table)

Four wine-bottle coolers in the form of the colossal ancient marble 'Warwick Vase' by Paul Storr, 1812. The fluted stands also by Storr, 1813–16

Pair of ewers and stands by Rundell, Bridge & Rundell, 1822. Made for George IV

Centrepiece modelled by Edmund Cotterill for Garrards, 1842, from designs by Prince Albert. It incorporates portraits of Queen Victoria's favourite dogs

Two from a set of twelve four-light candelabra by Paul Storr, 1804–12. Made for George IV

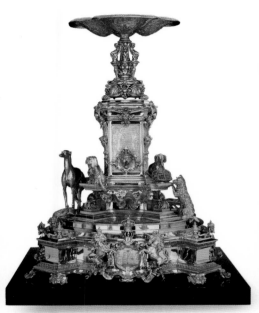

Silver-gilt centrepiece designed by Prince Albert, modelled by Edmund Cotterill and made by Garrards, 1842. It includes portraits of the royal couple's favourite dogs: the greyhound Eos, the dachshund Waldman, and the Highland terriers Cairnach and Islay.

As originally completed, the walls of the State Dining Room were painted a warm stone colour, which was first replaced in crimson damask in 1965–6. Before the creation of the Ballroom, the deep recess at the southern end of the State Dining Room housed the buffet on which a display of gold plate would be mounted for important dinners. Since Queen Victoria's reign the room has been used for dining on special occasions. In the reigns of King Edward VII and King George V, a dinner was held each year on Derby Day in early June. In more recent times the room was used by Her Majesty The Queen to entertain European and Asian leaders in 1998, and by The Prince of Wales on the occasion of the opening of The Queen's Gallery in 2002.

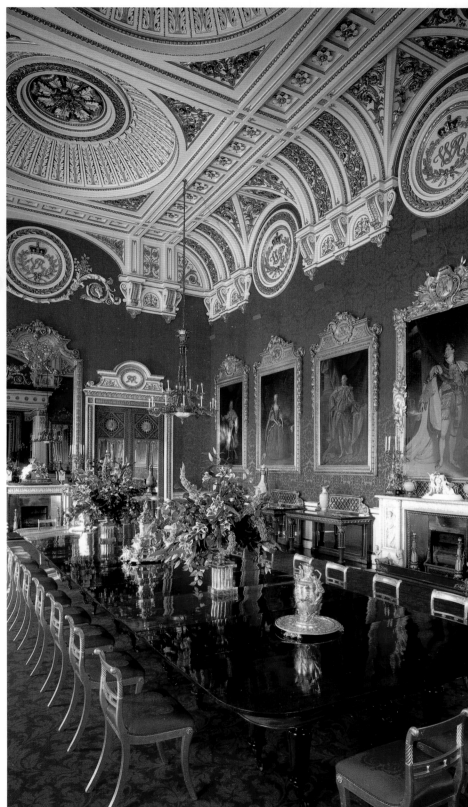

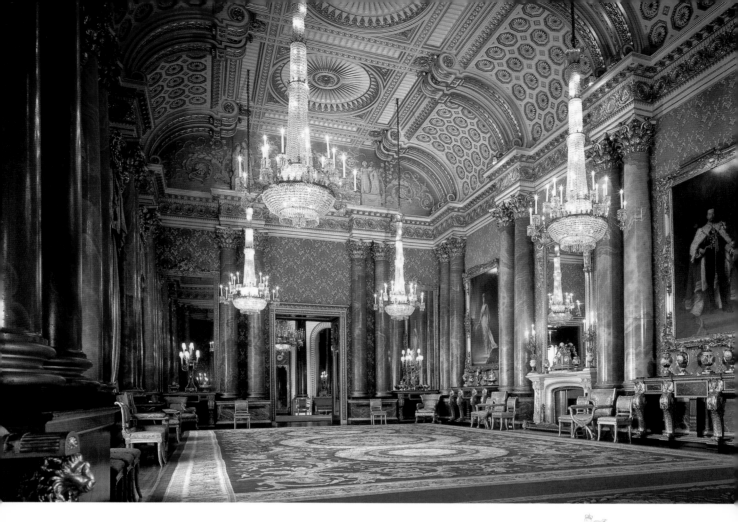

The Blue Drawing Room

Nash's plan provided two large drawing rooms, known simply as the North and South Drawing Rooms, either side of the central Bay Drawing Room. These rooms are now known respectively as the White and Blue Drawing Rooms and the Music Room. The Blue Drawing Room, which is the farthest of the three from the private apartments, was effectively the ballroom of the Palace before Pennethorne's additions of 1855–6. The room must originally have been even more startling. The thirty columns were made by Joseph Browne in scagliola of a colour variously described as 'porphyry' and 'raspberry', the walls were hung with crimson silk and the curtains and pelmets were of crimson velvet. The columns were painted in 1860 to resemble onyx, in itself a masterpiece of *trompe-l'oeil*, while the blue flock wallpaper was hung at the direction of Queen Mary. The marble chimneypiece with boldly carved foliage and classical motifs is attributed to Richard Westmacott.

A CELEBRATION OF POETRY

The plaster sculpture that is such a feature of the interior of the Palace reaches new heights in the four large arched spaces above the cornice containing figures by William Pitts. William Shakespeare, John Milton and Edmund Spenser are each enthroned in triumph, accompanied by nymphs and cherubs, and modelled almost in the round against a gilded ground. The fourth relief is a generalised evocation of the art of poetry. It is remarkable that whereas themes of victory were *de rigueur* for the external sculpture at Buckingham Palace, and for contemporary interiors such as the Waterloo Chamber at Windsor Castle, the principal drawing room of the British Sovereign celebrated the nation's poets rather than its military might.

THE TABLE OF THE GRAND COMMANDERS (1806–12)

This circular table is in hard-paste Sèvres porcelain with gilt-bronze mounts. The top is decorated with portraits of Alexander the Great and twelve other great commanders of antiquity, including Julius Caesar, Hannibal and Pompey, painted by Louis-Bertin Parant in imitation of antique cameos. The ormolu mounts are by Pierre-Philippe Thomire. The table was commissioned by Napoleon in 1806 when, as the conqueror of all Europe and recently crowned emperor, he was at his apogee and saw himself as a modern Alexander. It was not finished until 1812 and remained in the Sèvres factory until after Napoleon's final defeat in 1815. Two years later it was presented to George IV, when still Prince Regent, by the restored French king, Louis XVIII, in gratitude for the allied victory over Napoleon. George IV instructed Lawrence to include the table in his State Portrait (see page 16).

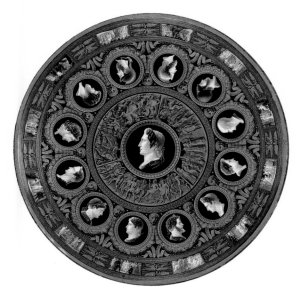

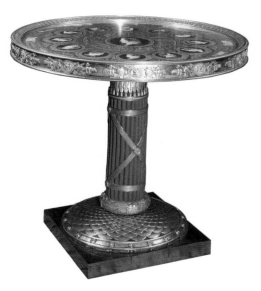

Pictures

Sir Luke Fildes (1843–1927), *King George V*, 1911–12

Sir William Llewellyn (1858–1941), *Queen Mary*, 1911–13

Furniture

Two pairs of marble and gilt-bronze side tables by A.L. Bellangé embellished with lapis lazuli and cornelian, *c.*1823. The gilt-bronze masks represent the Four Seasons. Purchased by George IV in 1825 for Windsor Castle

Parts of four sets of settees and armchairs by Tatham, Bailey & Sanders and Morel & Seddon, *c.*1810–28

Two pairs of gilt-bronze candelabra attributed to François Rémond, *c.*1787, probably acquired by George IV for Carlton House in the 1780s. There are two further pairs in the Music Room

Set of four cut-glass chandeliers, English, *c.*1810

Astronomical clock by Jean-Antoine Lépine, *c.*1790; as well as the time, the three enamel dials by Jean Coteau indicate the times of sunrise and sunset, the state of the moon, the date and the sign of the zodiac

Giltwood centre table with a late 17th-century Italian *pietra dura* top

Porcelain

Sèvres porcelain vases painted with a dark blue (*bleu lapis*) ground, second half of the 18th century

Astronomical clock by Jean-Antoine Lépine, c.1790

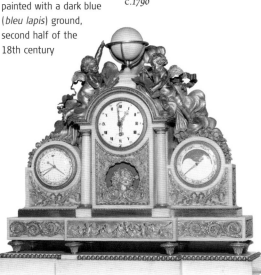

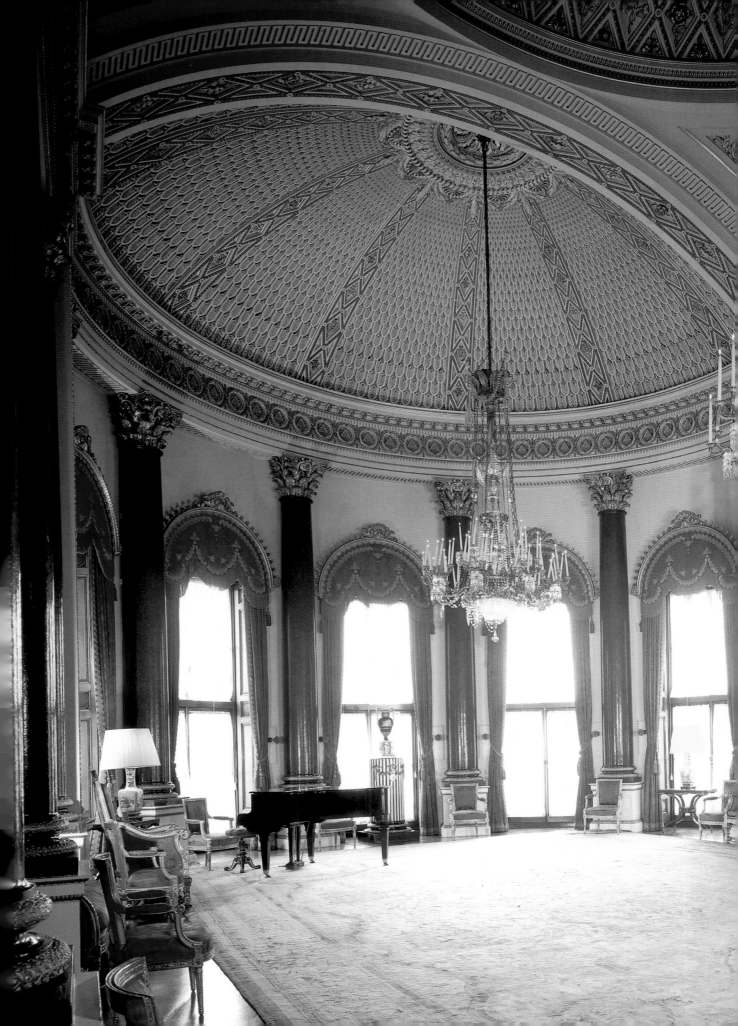

THE MUSIC ROOM FLOOR

A spectacular feature of the Music Room is its parquet floor of satinwood, rosewood, tulipwood, mahogany, holly and other woods. This was made by Thomas Seddon and cost over £2,000. Inlaid with the cipher of George IV (above), it is a triumph of English craftsmanship and one of the finest of its type in the country.

Furniture

Carved and gilt throne chairs made for the use of King George V and Queen Mary when Prince and Princess of Wales at the coronation of King Edward VII in 1902

Carved and giltwood armchairs and settees by Georges Jacob, c.1786, supplied to George IV through Dominique Daguerre

Boudoir grand piano by John Broadwood & Sons, 20th century

Patinated and gilt-bronze vase by Pierre-Philippe Thomire (1751–1843) on an ebony and brass fluted pedestal, early 19th century; the vase was bought by George IV in 1812

Pair of English chandeliers of cut-glass and gilt-bronze, early 19th century

Porcelain

Soft-paste Sèvres porcelain vases; those on the left-hand chimneypiece were supplied by the factory as a ready-made *garniture de cheminée* in 1764

The Music Room

The Music Room lies at the centre of the West Front, facing the garden. Ranged around its walls are sixteen scagliola columns, imitating lapis lazuli. The frieze here and in the two adjoining drawing rooms incorporates a device formed of a triangle within a garland which is entirely original and may derive from masonic imagery. Both Nash and his patron George IV were Freemasons.

Above the frieze are three more plaster reliefs of infants by William Pitts, representing the Progress of Rhetoric. The subjects are *Eloquence* (opposite the windows), *Pleasure* (over the door to the Blue Drawing Room) and *Harmony*.

No less impressive than the ceiling but less visible, the floor is an outstanding example of parquetry by Thomas Seddon, one half of the firm of Morel & Seddon, which was formed to furnish Windsor Castle at the same time as Buckingham Palace was being built. Inlaid with holly, rosewood, tulipwood and satinwood, it cost £2,187 3s. In his evidence to the Parliamentary Select Committee on the Buckingham Palace project in 1831, Seddon proudly predicted that 'at fifty years hence it would be as good as it is now; you might drive carriages over it'.

The Music Room is used occasionally for private recitals, and plays a more general part in royal entertaining in conjunction with the other state apartments. The room is also used for royal christenings. The Queen's three eldest children were all baptised here with water brought from the River Jordan.

Sèvres porcelain vase à batons rompus, 1764, acquired by George IV. The painted scene is copied from the work of the Dutch 17th-century artist David Teniers the Younger.

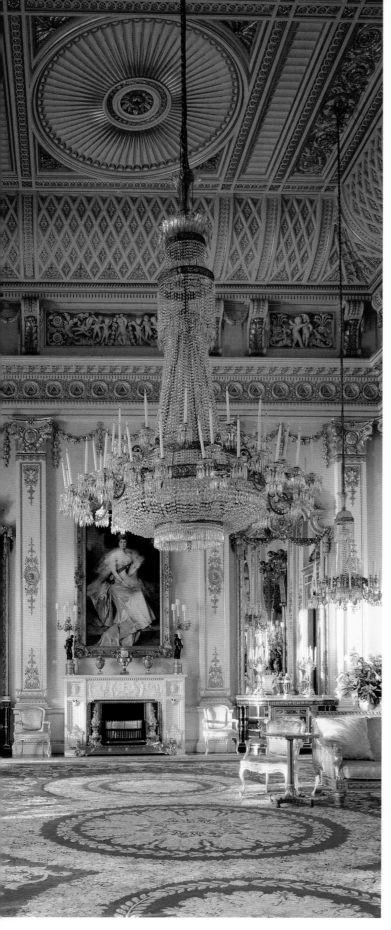

The White Drawing Room

For the 'North Drawing Room' Nash reserved one of his most original ceiling designs. As elsewhere, the flat 'bed' is composed of radiating circles within a rectangular framework, but the cove is reversed in a manner that recalls some of his earlier work for George IV at Brighton Pavilion. Beneath the cove there is more sculptural decoration in plaster by William Pitts.

The room is articulated by giant pilasters of an order that is entirely Nash's invention, incorporating a Garter Star and the winged motif which Nash first used in this way in the Saloon at Brighton Pavilion, and which also appears on the doors throughout the state rooms. The pilasters were originally supplied by Joseph Browne in a yellow scagliola (imitating Siena marble) which has subsequently been painted over, and the room was hung and upholstered in a gold-and-white figured damask.

At each end of the room two pairs of ebony-veneered cabinets with gilt-bronze mounts are built into the wall beneath tall mirrors. They were made in France, perhaps by Adam Weisweiler, and incorporate panels of *pietra dura*. They were extended for use here by the addition of the side shelves, and one of them (in the north-western corner) was incorporated into a concealed door. When opened, the mirror and cabinet move as one to provide members of the Royal Family with a discreet means of entering the state rooms from the private rooms beyond. It is here that guests are presented to The Queen during the many receptions held in the state rooms during the year.

One of the plaster friezes by William Pitts.

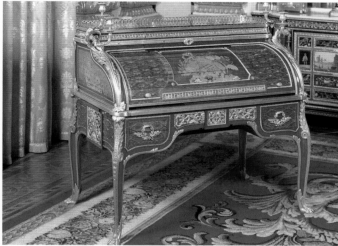

Pictures

François Flameng (1856–1923), *Queen Alexandra*, 1908; she wears the small diamond crown made for Queen Victoria and worn in the latter years of her reign

After Joseph Vivien (1657–1735), *François de la Mothe-Fénelon, Archbishop of Cambrai*, c.1700

After Sir Anthony Van Dyck (1599–1641), *Portrait of a man in armour*, c.1650

Sir Peter Lely (1608–88), *Portrait of a woman*, c.1658–60

Furniture

Roll-top desk by Jean-Henri Riesener (1734–1866), veneered with fret marquetry inlaid with trophies and flowers and mounted in gilt-bronze, c.1775; the desk was probably made for one of the daughters of Louis XV. It was purchased by George IV in 1825

Set of French cabriole-legged giltwood armchairs by Jean-Baptiste Gourdin, mid-18th century

Piano by S. & P. Érard supplied in 1856, in a gilded case painted with *singeries* by François Rochard (1798–1858) in imitation of a panel from an older instrument which was let into the lid of the piano at Queen Victoria's request

Four French ebony and gilt-bronze pier cabinets with 18th-century *pietra dura* panels, adapted in England in the 1830s to fit the room

Set of five English cut-glass and gilt-bronze chandeliers, early 19th century (remade in 1877)

Set of four late 18th-century French gilt and patinated bronze candelabra in the form of a faun and nymph holding cornucopiae, on gilded wood pedestals in the form of cranes, supplied for Carlton House by Tatham, Bailey & Sanders, 1811

Two pairs of gilt-bronze candelabra by Pierre-Philippe Thomire (1751–1843), early 19th century; bought by George IV in 1813

Four further pairs of French patinated and gilt-bronze candelabra, late 18th century, of which one pair was formerly in the Throne Room at Carlton House

French marble mantel clock with patinated bronze figures and gilt-bronze mounts, late 18th century

Porcelain

Sèvres porcelain vases, second half of the 18th century

Pot-pourri stand designed for the Saloon at Brighton Pavilion by Robert Jones, incorporating an 18th-century Chinese celadon vase with painted tin (*tôle peinte*) elements, gilt-bronze mounts by Samuel Parker and a marble base by Henry Westmacott, 1822–3

ABOVE LEFT: *Piano by S. & P. Érard in a gilded case decorated in 18th-century style by François Rochard, 1856. The lid incorporates that of an earlier instrument supplied to Queen Victoria in 1838.*

ABOVE RIGHT: *Roll-top desk by Jean-Henri Riesener, veneered with fret marquetry and inlaid with trophies and flowers, c.1775. Purchased by George IV in 1825, it may have been made for one of the daughters of Louis XV.*

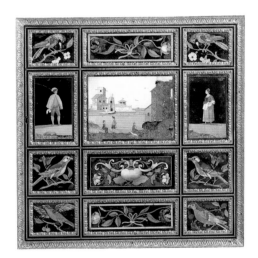

Detail of the pietra dura *plaques on one of the four pier cabinets.*

John Hoppner, George IV when Prince of Wales, *c.1796*

The Ante-Room

The Ante-Room was formed by Edward Blore to link the private and state rooms; it is connected by doors to the Picture Gallery, the Throne Room and the Royal Closet, an ante-room to the White Drawing Room. The low ceiling enabled the accommodation of a band room in the space above, with a balcony overlooking the Picture Gallery.

Pictures

Heinrich von Angeli (1840–1925), *Princess Victoria Mary of Teck* (later Queen Mary), 1893

Karl Schmidt of Bamberg, after Winterhalter, *Prince Albert,* painted on porcelain, second half of the 19th century

Heinrich von Angeli (1840–1925), *Princess Beatrice* (Princess Henry of Battenberg), 1893

Heinrich von Angeli (1840–1925), *Princess Helena* (Princess Christian of Schleswig-Holstein), 1875

Edward Hughes (1829–1908), *The Duchess of York* (later Queen Mary), 1895

Heinrich von Angeli (1840–1925), *Princess Louise* (Marchioness of Lorne), 1875

Furniture

Two French knee-hole writing desks (*bureau mazarin*) veneered in Boulle marquetry with tortoiseshell and brass, late 17th century

French kingwood parquetry chest of drawers of Louis XV design, with gilt-bronze mounts, 19th century

English circular table with rosewood top, the base by Morel & Seddon, 1820s

Sculpture

Sir William Reid Dick (1878–1961), *Queen Mary*, bronze, 1938

Harry O'Hanlon (b.1915), *Family of the horse*, bronze, 1988; presented to HM The Queen in 1990

M. Moch, *Two loons* (Canadian sea birds), green soapstone, 1990; presented to HM The Queen by the Prime Minister of Canada during the royal visit of 1990

The Ministers' Staircase

This secondary staircase was also introduced by Blore, providing alternative access to both the private and state rooms. The strict economy enforced on the completion of the Palace after the death of George IV is indicated by the balustrade, which was formed in gilt lead in place of the bronze used for the Grand Stair. The wall opposite the landing was originally lit by a tall window, which at the end of Queen Victoria's reign was fitted with a stained-glass memorial to Prince Albert Victor, Duke of Clarence and Avondale, the eldest son of Albert Edward, Prince of Wales, who died in 1892.

Picture

John Hoppner (1758–1810), *George IV when Prince of Wales*, c.1796

Tapestries

Two panels from a set of four of *Les Amours des Dieux*, woven at the Gobelins manufactory after designs by Joseph-Marie Vien, late 18th century; bought by George IV in 1826

Furniture

French 19th-century mahogany and bronze centre table with green marble top

Double-pendulum regulator ordered by George IV in 1825 from Abraham-Louis Breguet at a cost of £1,000; the clock has twin dials and twin movements. It was designed for extreme accuracy, and the reciprocal action of the two pendulums reduces any error of timekeeping by half

(at the foot of the stairs) Barometer and pedestal attributed to Jean-Pierre Latz, Boulle marquetry with gilt-bronze mounts, *c.*1735

Sculpture

Mowlm, *Five Inuits tossing a child in a blanket*, green soapstone, 1977; a Silver Jubilee present to HM The Queen

(at the foot of the stairs) Antonio Canova (1757–1822), *Mars and Venus*, c.1815–17; commissioned by George IV following Canova's visit to England in 1815 and delivered to Carlton House in 1824

Empire regulator clock with two movements, ordered by George IV in 1825 from the clockmaker Abraham-Louis Breguet.

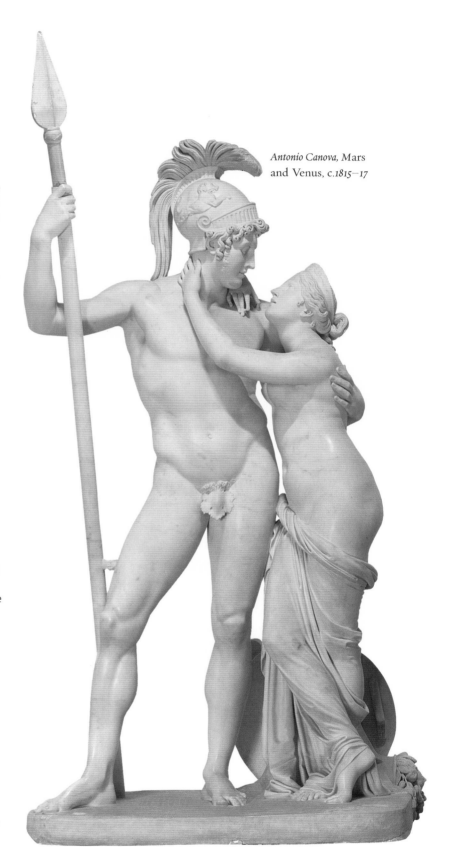

Antonio Canova, Mars and Venus, c.1815–17

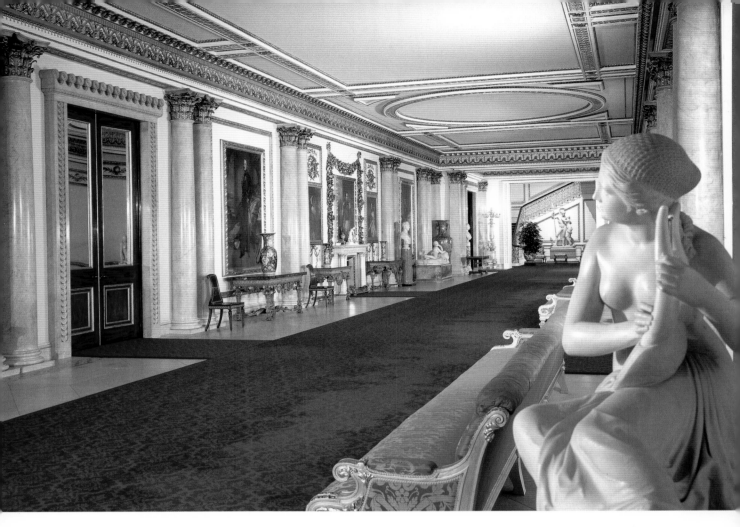

The Marble Hall

Lying directly under the Picture Gallery, the Marble Hall was originally designed for the display of sculpture. While suited in some ways to this purpose, lined with more of Joseph Browne's impressive marble columns and paved with coloured marbles, it was deficient in one crucial respect, namely natural light. Daylight was considered no less important for the viewing of sculpture than for pictures, and Antonio Canova was among the most persistent advocates of such conditions for his own works, three of which can be seen here. These substantial marble groups, and the two sea-nymphs by Emil Wolff and Carl Steinhauser, were in fact displayed in the Picture Gallery and Silk Tapestry Room during the nineteenth century. Their plinths, in English alabaster and blue Hymettian marble, were designed by Frank Baines for those settings in 1915. The remainder of the sculptures now in the Marble Hall are further examples from the notable collection commissioned by Queen Victoria and Prince Albert from sculptors working in Rome. Like those in the Grand Hall, these were brought here from Osborne at King Edward VII's direction after 1902.

Apart from the columns, the floor and the two marble chimneypieces (which were removed from Carlton House), the decoration of the Marble Hall is fundamentally also the work of King Edward VII and his decorators, C.H. Bessant. In the process the giltwood swags and pendants of fruit and flowers were moved here from the east wing.

Damascened steel table by Placido Zuloaga, 1880

Pictures

(West wall, from the Ministers' Staircase)

Domenico Pellegrini (1759–1840), *Augustus, Duke of Sussex, c.*1804

Frans Xaver Winterhalter (1806–73), *Victoire, Duchess of Nemours* (cousin of Queen Victoria), 1840

George Dawe (1781–1829), *Ernest I, Duke of Saxe-Coburg and Gotha* (father of Prince Albert), *c.*1818–19

Franz Xaver Winterhalter (1806–73), *Victoria, Duchess of Kent* (sister of the above and mother of Queen Victoria), 1849

Franz Xaver Winterhalter (1806–73), *Prince Albert*, 1859; in the uniform of a colonel in the Rifle Brigade

Franz Xaver Winterhalter (1806–73), *Queen Victoria*, 1859

(East wall)

Eduard von Heuss (1808–80), *Charles, Prince of Leiningen* (Queen Victoria's half-brother), 1841

Sculpture

(from the Ministers' Staircase)

Neilsine Caroline Petersen (1851–1916), *Christian IX, King of Denmark* (father of Queen Alexandra), 1906

Neilsine Caroline Petersen (1851–1916), *Louise, Queen of Denmark* (mother of Queen Alexandra), 1906

Antonio Canova (1757–1822), *Fountain nymph*, 1819; originally ordered in 1815 by John Campbell, 1st Baron Cawdor, who relinquished the commission to George IV

John Francis (1780–1861), *Ernest I, Duke of Saxe-Coburg and Gotha* (father of Prince Albert), 1846; the bust was modelled posthumously under Prince Albert's supervision

Emil Wolff (1802–79), *Sea nymph with trident*, 1841

Carl Steinhauser (1813–79), *The Siren*, 1841

Antonio Canova (1757–1822), *Dirce*, 1824; commissioned by George IV in 1820

Eduard Müller (1828–95), *Psyche*, 1861

Joseph Engel (1815–1901), *The nymph Clotho*, 1860

William Theed (1804–91), *Victoria, Duchess of Kent* (Queen Victoria's mother), 1862

Furniture

Carved and gilt gesso table by James Moore with the royal cipher of George I, *c.*1715

Two carved and gilt side tables with green marble tops, attributed to Jean Pelletier, 1701

Spanish damascened steel table made by Placido Zuloaga for Alfred Morrison, 1880; purchased by Queen Elizabeth in 1938

Gilt-bronze and biscuit porcelain mantel clock by Benjamin Vulliamy, *c.*1780

Two pairs of Derbyshire spar ('blue-john') and gilt-bronze vases by Matthew Boulton, late 18th century

Pair of large Chinese *cloisonné* enamel vases, early 20th century; given to King George V and Queen Mary by the Emperor of China on their coronation in 1911

Two pairs of tall carved and giltwood torchères; the first pair made by Bogaerts & Storr in 1807 for the Old Throne Room at Carlton House, the second made to match these by Morel & Seddon, 1826–8, when all four were installed at Windsor Castle

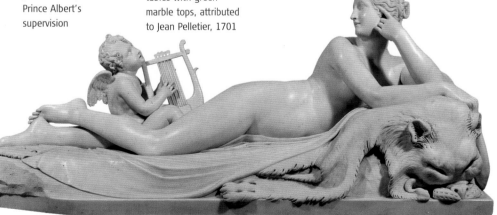

Antonio Canova (1757–1822), Fountain nymph, *1819*

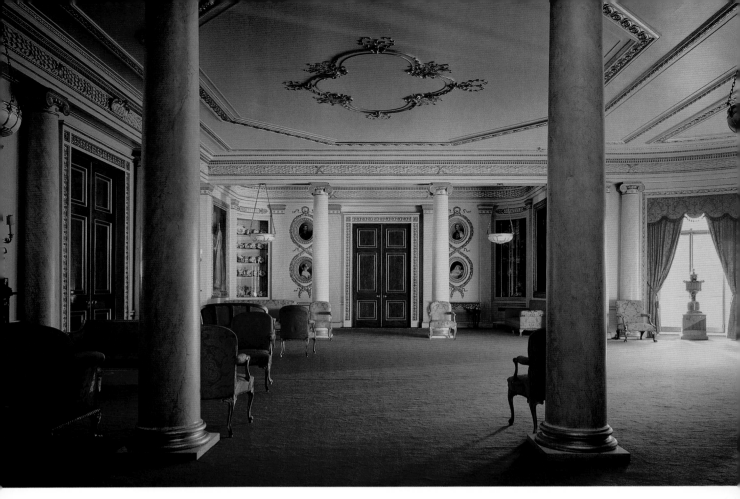

The Bow Room

This ample room was originally intended as a Library, at the centre of the suite of rooms on the ground floor which were to have served as George IV's private apartments. When the Palace was eventually occupied by Queen Victoria, these rooms were adapted to serve as drawing rooms for the newly reorganised Royal Household. The Bow Room was redecorated in 1853, the date included in the ceiling plasterwork, when it was used for the christening of Queen Victoria's youngest son, Prince Leopold. It was in that year that Queen Victoria installed another of her favourite 'dynastic' arrangements of portraits; the ovals in gilt frames set into the walls represent members of European royal families related to Queen Victoria, including those of Belgium and Hanover. The two black marble chimneypieces with gilt-bronze mounts were originally supplied by B.L. Vulliamy for a house in Grosvenor Square in London and were subsequently moved to Castle Rising in Norfolk. They were purchased by Queen Mary and installed here in 1925 under the direction of Sir Charles Allom.

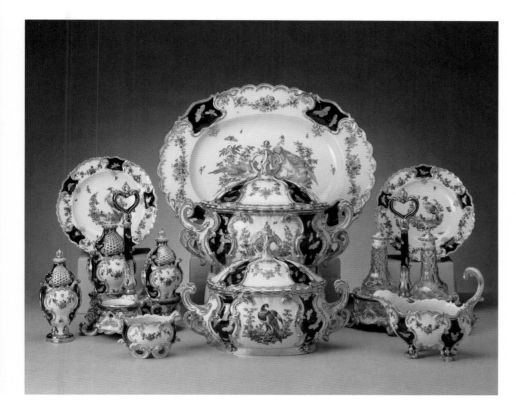

Part of the Chelsea porcelain 'Mecklenburg' service, made in 1763 for presentation to Queen Charlotte's brother, Duke Adolphus Frederick of Mecklenburg-Strelitz; presented to Queen Elizabeth in 1947 by Mr James Oakes.

The West Front

Extending over 80 metres (73 yards) in length, the garden front remains to some extent the Palace's 'private' façade, although it has long formed the backdrop to royal garden parties and since 1993 has been part of the public route. The façade remains substantially as designed by Nash. From later periods are the central half-dome and raised attic, which represent Edward Blore's reworking of Nash's controversial dome, and the massive block of Pennethorne's Ballroom at the right-hand (southern) end. The central bow, which Nash must have based on French eighteenth-century precedents such as Pierre Rousseau's Hotel de Salm, originally supported six Coade stone figures of Virtues by J.C.F. Rossi, supplied in 1836, with four military trophies. Like the parapet statues on the east side, these were removed as unsafe in the 1960s. The reliefs embedded in the upper walls to either side of the bow were designed by John Flaxman and carved by Sir Richard Westmacott in Malta stone. They represent scenes from the life of Alfred the Great and were completed in 1831. The Portland stone relief in the attic storey was also carved by Westmacott. It is formed from two

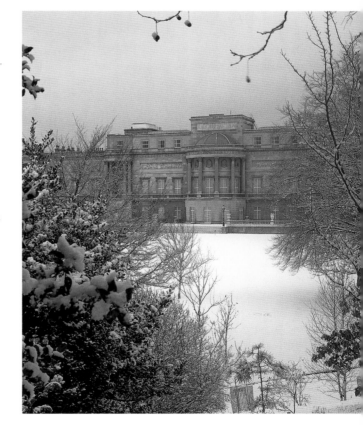

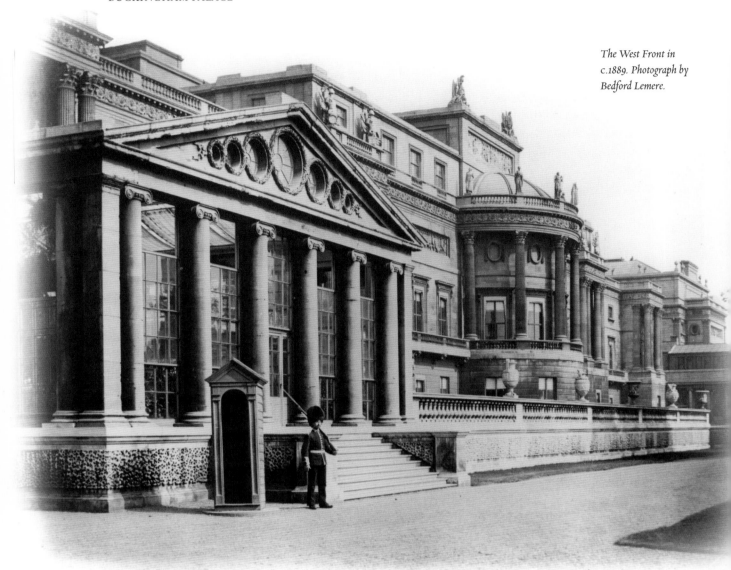

The West Front in c.1889. Photograph by Bedford Lemere.

separate reliefs which were originally to have been placed on the Marble Arch.

Along the terrace balustrade are twelve large vases. The six bell-shaped vases were modelled by Thomas Grimsley in 1829 and formed in Coade stone by William Croggon. The six oval urns are by Croggon's successor in business, J.M. Blashfield, and probably date from the 1830s.

The temple front that terminates the cross walk at its southern end was designed by John Simpson as part of the redevelopment of The Queen's Gallery in 2002. Its form is derived from the Temple of Isis at Pompeii.

Two of the Coade stone brackets supporting the first floor balustrade, supplied by William Croggon.

Looking across the lake towards the Wellington Arch on Hyde Park Corner.

The Garden

The 16-hectare (40-acre) garden forms part of an extraordinarily large and varied green landscape at the heart of London, comprising St James's Park to the east and Green Park to the north. It is a reminder that Buckingham House, which George III purchased in 1762, lay right on the edge of the city of Westminster, and today it provides a habitat for hundreds of plant and animal species. Nash, who had been much concerned with landscape design at Regent's Park and St James's Park, prepared the first designs for the laying out of the new Palace garden in around 1825, but no concerted campaign of work was undertaken until after his dismissal in 1831. The man charged with its eventual completion was William Townsend Aiton (1766–1849), who had served George IV for many years in charge of royal gardens at Kew, Carlton House and Brighton and in 1827 was appointed 'Director of His Majesties Gardens'. It was Aiton who created the lake and the Mound, a high artificial bank on the southern side that screens the garden from the Royal Mews.

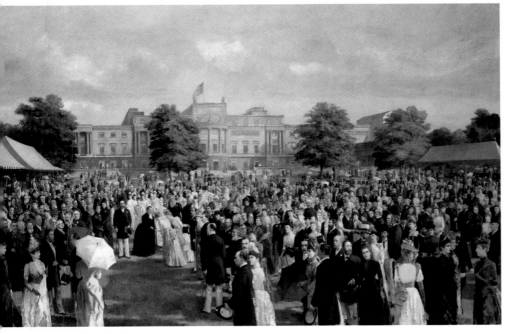

LEFT: *F. Sargent,* Queen Victoria's Golden Jubilee Garden Party, *1887–9*

The children's garden party held to celebrate the 50th Anniversary of the Coronation, 2003.

Today the garden is the setting for The Queen's garden parties, of which five are usually held in July, each for around eight thousand guests. In 2002 The Queen's two Golden Jubilee Concerts were each attended by twelve thousand members of the public. Presenting classical and pop music on separate nights, they took place in an unprecedented atmosphere of informality and celebration. During the rest of the year the extensive lawns provide a landing site for The Queen's helicopter.

At the end of July each year the tents for the service of tea and other refreshments and the temporary bandstand rapidly make way for the buildings erected for the use of summer visitors. From these, the route passes along the southern side of the garden before turning along the far side of the lake to the exit on Grosvenor Gate.